# Great Works

# Great Works

Encounters
with Art

Michael Glover

PRESTEL
Munich · London · New York

for Ruth

*Per gli occhi fiere un spirito sottile,*
*Che fa in la mente spirito destare,*
*Dal qual si mouve spirito d'amare,*
*Ch' ogn' altro spiritello fa gentile*

— Guido Cavalcanti, Sonetto XIII

# Contents

# The Poet's Eye

James Bradburne

Director General, Pinacoteca di Brera, Milan

It is difficult to know how to write about Michael Glover's art criticism in isolation. Were either of us different people, I could adopt the dispassionate tone of objective authority: 'Michael Glover is an exceptional critic in a field already distinguished by great writing and deep insight, a field that includes Ingrid Rowland, Tim Parks and others.' This would all be true, but it would not do justice to the breadth of my relationship and the depth of my friendship. For Michael is not only an art critic and a poet; he is also a friend.

I am a museum director and an exhibition maker, and Michael has been reviewing – critically – my work for nearly two decades. We first met at the Museum of Applied Art in Frankfurt (which I directed from 1999 to 2003) when he came to review *I Love You*, an exhibition on computer viruses curated by Franziska Nori. I argued that the subject was a cultural phenomenon and possible candidate for consideration as a form of concrete poetry. Michael, with a reputation as a fine poet, was the obvious choice to review the show, and rather reluctantly he was persuaded by our press officer to come to Frankfurt. I still remember his posture as he cast a glaucous eye on the row of unremarkable computers on which hackers had installed their masterpieces. He listened to my well-practised synopsis with patient reserve, but little sympathy, until we came across two wild-haired young hackers finishing their installation. He turned to them and said, 'So tell me what this means.' He was shocked to hear them describe in loving detail the way in which the code 'spoke' to them – not only its meaning but its underlying structure, its form and, ultimately,

its beauty. Clearly for them code was a language, and like all languages, it had the potential of becoming literature, even poetry. I cannot claim he was won over, but from then on he found ways to review the exhibitions I produced, at mak.frankfurt, and then from 2006 at the Palazzo Strozzi in Florence.

Michael sees a great many exhibitions, but this doesn't mean he is a greenery-yallery pushover for art. On the contrary. As an exhibition maker, in my bleakest moments of self-doubt, I have wondered why people bother to go to exhibitions at all. The taste for wandering about surrounded by objects badly lit and poorly interpreted is certainly an acquired taste, if Bertie Wooster's opinion can be trusted.

> I have never been much of a lad for exhibitions. The citizenry in the mass always rather puts me off, and after I have been shuffling along with the multitude for a quarter of an hour or so I feel as if I were walking on hot bricks. [...] I mean to say, millions of people, no doubt, are so constituted that they scream with joy and excitement at the spectacle of a stuffed porcupine fish or a glass jar of seeds from Western Australia – but not Bertram.
>
> (P.G. Wodehouse, 'The Rummy Affair of Old Biffy', in *Carry On Jeeves*, 1925)

Bertie's (and oddly my own) doubts about the exhibition medium are also shared by Michael Glover, as are the means of judging the work's success:

> There is a crude way of testing the value of any work of art. It is called the Ten-Second Test. If any work of art is worth staring at for as long as ten seconds, it stands a chance. That's it. Most works of art – and especially those which are being made today under the name of 'art' – fail that test miserably. Three seconds, perhaps four, are quite enough.
>
> ('The Steely, Ascetic Countenance of a Cunning Diplomat')

The research bears him out – the average time a visitor normally looks at any particular painting in an art exhibition is only about six seconds, and most of the time we spend in galleries is spent shuffling listlessly, squinting at the badly lit and even more badly written labels pasted on tiny scraps beside the artwork, which only serve to attract a crowd of knowledge-thirsty exhibition goers, who then block the view of the painting to anyone else. Six seconds is a generous estimate.

After decades of paying close attention to art, Michael has developed a keen eye, a sharp tongue and the instincts of a museum professional. With other critics, this intimacy can become a vice, as the critic's eye is no longer in tune with that of the reader. The trained eye is often blind to the beauty the naïve eye still sees. This is where being a poet helps, with poetry's relentless discipline of returning to the startling freshness of the world. Nelson Goodman once called the museum 'an institution for the prevention of blindness', which is as good a definition as I can propose. The poet helps us cure the eye both jaded and dazzled by the contemporary world's surfeit of images. Michael's touch is sure, his phrases terse and lapidary, his gaze – held for at least ten seconds – deep and insightful. The poet is anything but blind:

> The point of a flea is that it is peskily small, and, from a physical point of view, utterly insignificant. [...] This flea, on the other hand, looks quite the opposite. This self-vaunting monster looks like a creature of some moment, not to be easily cast aside or screwed into nothingness beneath a careful thumb. [...] It has all the tremendous muscular allure of a male nude by Michelangelo. Malignity writ large then. Yes, it seems to have all heaven in its tow: all those shooting stars, fresh snatched from some tree in the children's nursery, look as if they are dancing attendance upon it as they fizz and roar at its back. It looks like some magician which is about to yank a trick out of its acorn cup. In short, it has a

wonderful, commanding presence. The natural world seems to pivot about it. This flea is determined to get somewhere.

('The Overbearing Monstrousness of the Visionary Moment')

A.E. Housman famously admired critics more than artists (to the dismay of G.H. Hardy), and wrote, 'Whether the faculty of literary criticism is the best gift that Heaven has in its treasures, I cannot say; but Heaven seems to think so, for assuredly it is the gift most charily bestowed. Orators and poets [...] if rare in comparison with blackberries, are commoner than returns of Halley's comet: [literary] critics are less common.' Michael Glover is a rare critic in a now crowded field, and has the power to transform the hard work of criticism into intellectual play, inviting us to join him in solving the riddle that every great work of art represents.

> We could propose that [the inconsistencies of this painting are] the consequence of Bronzino having bitten off more than he could chew, that he did not quite possess the painterly expertise to get this enormously complicated composition quite right. (This is his first attempt at the theme. The second, in Budapest, is much more straightforward and academic in its approach.) That's nonsense though – he was simply too great a painter. So he has us on the end of a spit, and, quite gently, he turns it. What a tease.
>
> ('The Medici Court Painter's Bewitchingly Twisty Carnality...')

Above all, Michael Glover is a poet, enormously aware of the hard work of making words work. This love of craft shines through in his admiration for certain artists and certain works:

> What then is happening here? Here is a carpenter, a maker with his hands. He holds an axe, a chisel. This man is Russia. This man is at the heart of things. The wood which he works is on the move,

slipping sideways, part-worked, coming into being as an architectural structure of a certain Russian timelessness. See that ornamental window behind him? And yet this carpenter is being seen through the eyes of the stylisations of the modern, all those paintings by Picasso, Matisse and others that Malevich had seen in the Moscow homes of two great collectors, Morozov and Shchukin, earlier in the century, and the later experiments of the so-called Cubo-Futurists. Malevich was in the thick of all that.

('The Mute Maker in a Fatherland of Nostalgia')

Michael's gaze penetrates far beneath the surface of the painting.

Alas, all was not to go well after all. Death swept her off her feet when she was barely twenty-five years of age. Sweet creature, no sooner blown but blasted, as some court poet might have been found murmuring, from the wings.

('Sweetly Tweaked Creature, No Sooner Blown but Blasted')

'No sooner blown but blasted' – who but a poet, quoting another poet, could write an observation as terse?

An art critic, a poet and a friend. As an art critic, Michael did not pull his punches, and when he came to visit Florence to review our exhibition on Galileo at the Palazzo Strozzi, he didn't hesitate to express his profound reservations:

In spite of the fact that this is a 16th-century building, the show itself is contained – more constrained than contained [...] Everything feels pent, cornered and thrust forward, a-throb with scientific significance. The effect is dazzling – but also rather strangulatory. In spite of the fact that the spaces within the buildings themselves have great processional possibilities, there is no sense of pacing at all, and when we do finally come across

Galileo and evidence of his astonishing achievements in those final rooms, it comes as something of a shock – like suddenly meeting a human being on a corner in the middle of the night. And then, all of a sudden the exhibition ends, and you feel you have hit a brick wall, and are being kicked out into the street.

('Galileo: Images of the Universe from Antiquity to the Telescope, Palazzo Strozzi, Florence', review by Michael Glover, *The Independent*, 16 April 2009)

He was right – it was a failed experiment, from which I learned a great deal, lessons which were ultimately put to good use in creating the next exhibition, *Art & Illusions* (2009), and ultimately *Bronzino* (2010), *The Springtime of the Renaissance* (2013) and *Pontormo and Rosso Fiorentino* (2014). If we listen to good critics, good poets and good friends, the exhibitions we make are much the better for it. In the end, being a friend, Michael even wrote poetry for me at Palazzo Strozzi, in spring 2010. All the insight he has gained from decades of looking carefully at art finds its voice in his poetry, and his poetry, at least on this occasion, found itself in the exhibition *De Chirico, Max Ernst, Magritte, Balthus*, which, after all, is perhaps as it should be.

### La Sérénité du Savant

*Oh to see, wide-eyed, and never to be seen!*
*Oh to make sense of an arm,*
*To believe in the beauty of a coat of stone –*
*All this makes sense of being alone.*

# A Brief Note
# by the Author

Do not be too readily deceived. This is not a book of art criticism of the kind to which you might be accustomed. Nor is it a work of scholarship. There are no footnotes here, and no explanatory matter at the end. What you have here are three things: a blaring headline in which I have tried to encapsulate some sense of the inner nature and meaning of each work of art; its title; and some words about what I have seen in the form of a brief essay. And, oh yes, some very good pictures of what I am trying to describe.

This book is an account of a series of physical encounters. Highly personal. Immediate. Encounters which were often full of shock and surprise, amazement and delight. For that is my definition of a great work of art. It is that which shocks, amazes, surprises and delights. Week by week, as I practised my trade as an art critic for *The Independent*, I experienced these unexpected shocks. They were often almost physical shocks. And being shocking, they were entirely unpredictable – as turning a corner to be confronted by a scene of conflagration, naked flames rising to the skies, for example, can be wholly unpredictable if you were expecting yesterday's serenity, calmness, order.

Great art is not especially serene, calm and orderly – though, from time to time, it can be. It often sets your teeth on edge. It draws you into the aura of its presence, and then it is often rather reluctant to let you go. Some of the greatest works are forever calling you back to them, demanding that you look at them again and again – quite as bothersome as any human relationship, you might say. Such a work is Giovanni Bellini's great portrait *Doge Loredan*. You are never done

with this painting of this man. He is inexhaustible. And part of his inexhaustibility resides in this: you do not finally know why he has this hold over you. And so you need to return to the Sainsbury Wing of London's National Gallery in order, once again, to endeavour to unpick his mysteries. This book is an account of my attempts to unpick many mysteries. And, having read it, you must go to see these works for yourself. I challenge you to be challenged by them too.
I would probably prefer it if you disagreed with me about this, that and the other. Then we could sit down and have a proper conversation about art and why it matters.

# The
# Overbearing
# Monstrousness
# of the
# Visionary
# Moment

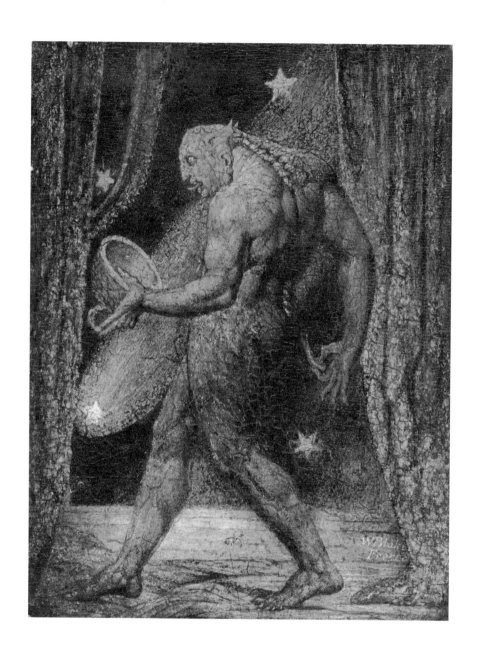

*The Ghost of a Flea* (c. 1819–20), William Blake,
21.4 × 16.2 cm (8 ⅜ × 6 ⅜ in.), Tate Britain, London

Blake's words and images – and especially when they form a part of one or another of the many illustrated Prophetic Books – often seem to have arrived as if from nowhere. Well, nowhere within reach of our immediate understanding. Angels and demonic beings loop around his words, transporting them goodness knows where. We are never a party to his visions. How could we have been? Nor even was his wife and faithful, life-long collaborator, Catherine. We can never know who or what spoke to him, or dictated to him the words or the images that he was said to have transcribed. We can only assume that he struggled to transcribe them faithfully – as far as he was able. It is for this reason that we often seem to be looking at the world of Blake through a glass darkly, in the words of St Paul.

What we do know is that the images are often violently at odds with the common world in which we move, breathe and have our being. They live in some strange, set-apart space of seemingly endless visual exaltation. And yet this is also not quite so. We do see, in part at least, where they come from. There is a great deal of religion in his work, but it seems to be the religion of a wild apostate from the core dogmas of Christianity – even allowing for the influence of Swedenborgianism. Jesus keeps some very odd company. There is also politics, but even some of Blake's politicians take on the aura of the supernatural. And what of insects? Does he have time for those too? Well, yes. All things, great and small, seemed to matter equally to him if we are to believe those great words of his in a poem called 'Auguries of Innocence': 'To see a world in a grain of sand [...] Hold infinity in the palm of your hand'. In Blake's world, the smallest things can be huge, and the loftiest, puny. It all depends upon their imaginative and emotional heft.

Take this image of a flea for example, so tonally dark, but also so magnificently enriched by gold across its dark mahogany surface. What kind of a flea is this? The point of a flea is that it is peskily small, and, from a physical point of view, utterly insignificant. As the Elizabethan poet John Donne once wrote to his lover, mockingly, and in a characteristically unholy mood: 'Mark but this flea, and mark in this / How little that which thou deniest me is'. A flea is utterly risible on account of its size, and, being small, it is therefore a thing of almost no consequence. It exists only to torment us.

This flea, on the other hand, looks quite the opposite. This self-vaunting monster looks like a creature of some moment, not to be easily cast aside or screwed into nothingness beneath a careful thumb. Fully embodied, it is striding the boards of what almost looks like a stage set (see those magical, drape-like trees – if that is what they are – to left and to right of it) – stepping out like a great Shakespearean actor. Its look is violently purposeful. Its huge ear sweeps back and up like an elaborate architectural feature. Its fingers are long and violently flexing. It stares long and long into the rimmed, bucket-like acorn cup that it is gingerly carrying in its left hand, as if summoning the future. In its right, it holds a nasty curling thorn. It has all the tremendous muscular allure of a male nude by Michelangelo. Malignity writ large then. Yes, it seems to have all heaven in its tow: all those shooting stars, fresh snatched from some tree in the children's nursery, look as if they are dancing attendance upon it as they fizz and roar at its back. It looks like some magician which is about to yank a trick out of its acorn cup. In short, it has a wonderful, commanding presence. The natural world seems to pivot about it. This flea is determined to get somewhere.

But how does this creature fit into the scheme of things? And can it really have been studied and anatomised by the eye of the artist?

Oh yes. According to Blake's friend John Varley, this was a flea which Blake himself saw – in a vision, of course. Here is what Varley wrote of the occasion:

> I felt convinced by his mode of proceeding, that he had a real image before him, for he left off, and began on another part of the paper, to make a separate drawing of the mouth of the Flea, which the spirit having opened, he was prevented from proceeding with the first sketch, till he had closed it. During the time occupied in completing the drawing, the Flea told him that all fleas were inhabited by the souls of such men, as were by nature blood-thirsty to excess.

Not only a flea to be painted then. Also a flea to be listened to, with rapt attention.

That drawing of the mouth of the flea is also in the Tate's collection.

# The Steely, Ascetic Countenance of a Cunning Diplomat

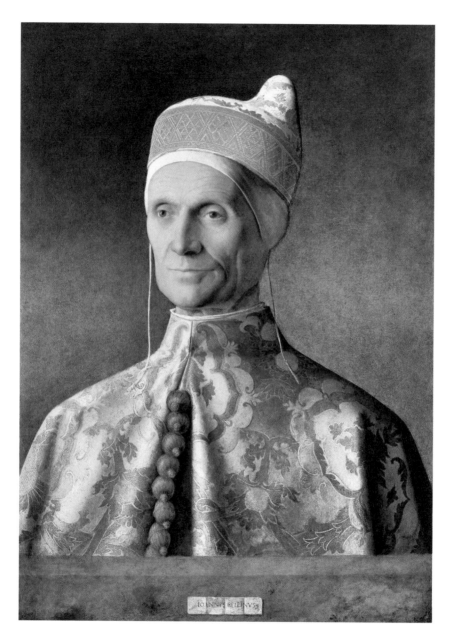

*Doge Loredan* (1504), Giovanni Bellini,
61.6 × 45.1 cm (24 ¼ × 17 ¾ in.), National Gallery, London

He utterly dominates Room 62 of the Sainsbury Wing of the National Gallery, this steely-eyed man, just as he would once have dominated the intricately vicious politics of Venice at the turn of the sixteenth century. I am referring to Doge Leonardo Loredan, as depicted by Giovanni Bellini, in a painting said to have been executed in about 1501, the year that the Doge took office – an office he was to hold, unbroken, for the next twenty years of almost ceaseless warfare between the Republic and her many enemies. To call this portrait arrestingly magnificent is to sell it short. It is one of the greatest and most startling portraits of the Western canon, painted by a man, the greatest painter of an entire family of remarkable painters, who was at the heart of the political and cultural life of Venice for the duration of his long life – Giovanni Bellini finally died in 1616, at the age of eighty-six.

There is a crude way of testing the value of any work of art. It is called the Ten-Second Test. If any work of art is worth staring at for as long as ten seconds, it stands a chance. That's it. Most works of art – and especially those which are being made today under the name of 'art' – fail that test miserably. Three seconds, perhaps four, are quite enough. To apply such a test to this portrait of the Doge would be laughable in the extreme. The more you stare at it, the more you become absorbed into the marvellously unsettling richness of its ambiguities. This work is inexhaustible. The more you look at it, the more it seems to say to you. In this respect, it resembles a great poem.

Surprisingly for a secular portrait, the Doge is not in profile, but face-on (well, in fact, just slightly askance) to the painter and the onlooker – this face-on mode of depiction, for most of the Middle Ages, was generally reserved for sacred portraiture. Now a Doge,

a mere mortal man, has been given the treatment once reserved for sacred subjects. And yet this man was not a king, and even less an absolute monarch – and we sense and feel this from the way in which Bellini has painted him. Monarchs more often than not look like over-stuffed balloons. They have little characterful reality, little genuine solidity. They are little more than the majestic way in which they are being represented. Think of Van Dyke's ridiculous portrait of Charles I on horseback, for example, galloping towards us like a bewigged crazy on a pantomime horse, or of Goya's glittering dismissals of the Spanish royal family whose court painter he was paid to be. More fools them! These paintings, for all their visual splendour, are often nothing but gloriously laughable pieces of puffery. They are lies.

The Doge, on the other hand, is at least two things at once. He is a human being spectacularly adorned in the vestments of his office: gorgeously brocaded mantle worked over, in gold thread, with pineapple motifs, which we can see upside down; a ducal cap – known as a 'corno' (an allusion to its single horn) – worn over a linen skull cap – but he is also the brutally focussed man that he needed to be in order to negotiate his way through the diplomatic challenges of being Doge of the Republic of Venice. This face is lean, wary, ascetic – almost to the point of revealing a slight tendency towards emaciation. A spiritual man then – but a spiritual man with an iron fist. It is the face of a master tactician, a diplomat. This is not a fat-faced Henry.

We are also a little surprised by the fact that the portrait is relatively modest in size – portraits of men of importance are usually as large as possible. This reminds us of the fact that the Doge was a man amongst men, elected by a committee of forty-one aristocrats, perpetually subject to checks and balances – and a man, moreover, who earned relatively little from his official duties; who was not allowed

to show favours to members of his own family; and whose right to own properties outside the Republic was severely restricted. And yet his ceremonial functions were extraordinary – and this is why he is tricked out in such splendour, in robes of such brilliance.

But he ends mid-chest, and he stands behind a marble balustrade, looking out towards the Grand Canal or the Piazza San Marco (or, since the middle of the nineteenth century, towards rivals for his attention at London's National Gallery), coolly appraising, almost rigid. Why is he cut off like this? Why is he not full-length? (By all accounts, he was not a short man, so he did not need to pretend.) Again, it is all to do with politics. The head-and-torso format of this portrait reminds us – and, I am sure, quite deliberately so – of Roman portrait busts. One great empire leads naturally on to another. It is also an attested fact that the Doge's family believed itself to be the direct descendants of a Roman hero called Caius Mucius Scaevola.

I too am a hero, he is telling us, a servant of God, a master amongst men, within strictly defined limits, of course, which I not-so-humbly acknowledge.

# The Cinematic Brashness of the Deaths of the World's Greatest Beasts

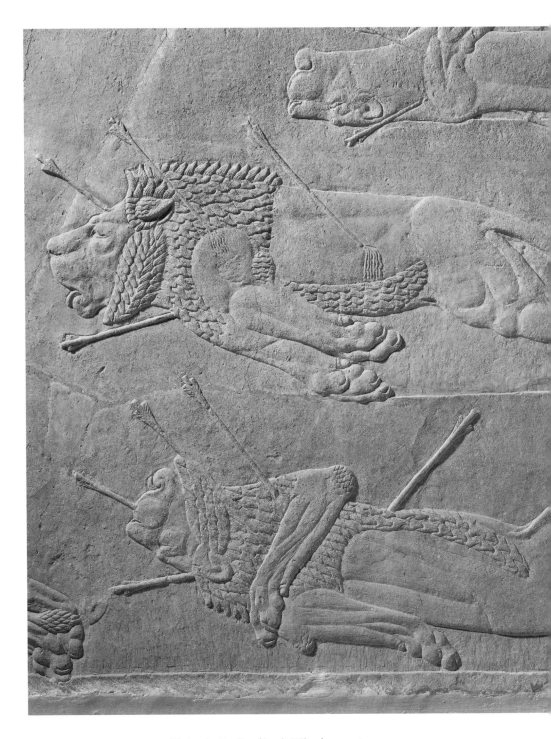

*The Assyrian Lion Hunt* (645–635 BC), unknown artist,
162.5 × 172.5 cm (64 × 67 ⅞ in.), British Museum, London

What we see on these pages – a brace of murdered lions – is a detail snatched from a sequence of low-relief sculptures created almost seven centuries before the birth of Jesus Christ. The entire work consists of a frieze of wall-mounted images of a hectic royal pursuit, carved into thick stone panels, which occupy an entire wall at the British Museum. The frieze of panels as a whole is a masterpiece, and it proves once again that great art is not necessarily easily divisible into small, portable rectangular units suitable for reproduction.

To find them, first pass between the two terrifying, human-headed winged lions from Nimrud that once flanked a doorway in the throne room of Ashurbanipal II (883–859 BC), and feel, as you do so, a passing sense of relief that these objects are protected from harm at the hands of barbarians by an institution such as this one.

The subject of the frieze is a lion hunt in the Assyria of Ashurbanipal, and the artist who executed this great work is the most accomplished and most prolific maker of art that the world has ever known: Anon. These massive panels – we marvel that the walls are robust enough to hold them – once embellished the walls of the North Palace at Nimrud, and they show the king engaged in one of his favourite pastimes: hunting down lions for sport. Lions were a public menace in Assyria in those days, but these lions were menacing only to a degree because they had been caged and prepared for ritual slaughter in an arena. After release they were driven towards the king's chariot and killed, one by one, by longbow, sword or the quick thrust of the dagger. In another panel, you can see the king's chariot closing in on the beasts.

Here we see two of them in their death throes, knobby, sinewy bodies stretched taut, manes ritualistically patterned; and what strikes

us is how modern their execution seems to be in spite of all its ancientness, and – the thought that follows on immediately – how ancient the tricks of art of more recent centuries (from, let us say, the Renaissance onwards) have always been. Here the great Assyrian fabricator plays games with our angle of view – we seem to see the lions partly from above, and partly from the side – and demonstrates an ability to create low-relief sculpture of a quality at least equal to that of Donatello.

The degree of realism shocks and appals. The lions, pinned down by arrows – surely far too many arrows – seem to be writhing and thrashing, and perhaps even pitifully roaring, in their death agonies, the near perfect embodiment of physical might reduced to a condition of pitiful helplessness.

The stone from which the lions have been released – that is the verb which seems most appropriate – is a dusty, pinky grey, wonderfully crumbly and flaky in its graininess, and entirely at one with the quality and the texture of an old lion's pelt. Other lions are shown humped or hunched or dragging their rumps after them along the ground. The sculptor leaves a lot of empty imaginative space – space for the leaping of lions, the release of arrows winging through the air, the tumultuous charge of the chariot – for this extended piece of choreography. It comes at us all at once as our eyes, blinking, scan it cinematically, left to right, right to left, a touch cowed, almost disbelieving.

# An Overwhelming Interior World of Troubling Tunnelling...

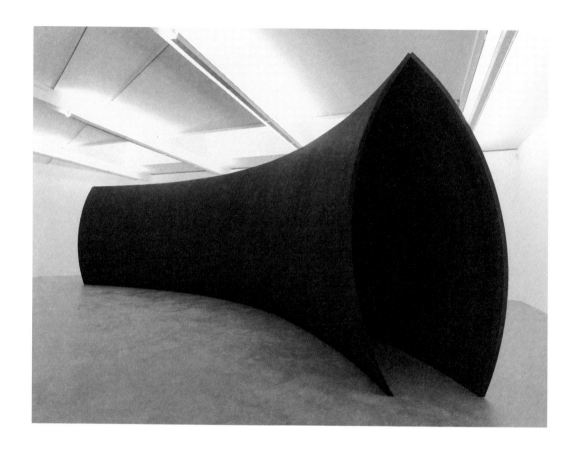

*Backdoor Pipeline* (2010), Richard Serra,
380 × 1,520 × 390 cm (149 ⅝ × 598 ⅜ × 153 ½ in.), Gagosian Gallery, London

How do we define the essential difference between a painting and a sculpture? Here is one attempt, and it is readily open to challenge. A painting is essentially a creature of the mind which flirts with timelessness, even when drawing attention to its own physicality. A sculpture, on the other hand, is an object which exists out in the world, in its own moment, and which defines itself within – and against – the space that it occupies.

We find ourselves wondering about the relevance and the accuracy of this rough and ready distinction as we stare at the heft and the physical immensity of one of Richard Serra's monumental sculptural forms in steel, an object that was three years in the making, and something that looks like a combination of a squashed doughnut of sorts and a sphere. It's a tricksy form, in short, inside and out, as illusionistic in its way as ... well, a painting perhaps. Serra's sculptures often demand audience engagement. You must immerse yourself, yield up your sense of self. In part, at least. Off we go then.

In this case two bowed sheets of steel rise, steepling, to an apex, where they lean together. The invitation is to enter, and you do so with a measure of trepidation because the interior pathway takes you on a long, leftward-tacking curve, which means that you can travel a considerable imaginative distance before you see a point of departure. The weathered surface is grainy and rusted to a rich ochre. You can appraise the outside from a distance – or not. As you wish. You have no such freedom once inside. There you are nose to steel, from end to end. These experiences – of inner and outer – are quite distinctly different from each other.

For a start, the exterior form seems to have a different shape when viewed from the left side or the right side. Stand at the sculpture's mouth – mouth? – and look at its left flank. Its rising curve seems relatively shallow. It seems to have a lighter hold on the ground, which is itself polished concrete. It is relatively dark in hue too. Look at the right-hand side, and much seems to have changed. That side appears less tall, and it bellows out plumpishly. What is more, it looks much more earth-cleaving, earth-rooted. Its colour is a rich, matt ochre, and it seems to possess the vertical ribbings of a pumpkin. It looks velvety to the touch.

Once inside you find yourself asking yourself: how am I experiencing this space as I move through it? That experience is enhanced, and made a little more complicated, by the fact that the London Underground passes underneath this gallery, one tunnel beneath another then... Light seeping in from both ends changes the colour of the interior walls depending on which direction you are walking. They go from black to ochre, ochre to black. A surface which has seemed to be leaning in to you begins to lean out as you retreat from it. One wall looks evenly ribbed, the other relatively smooth. Every way you turn, the sculpture seems to second-guess you, upend your ways of seeing, invite you to think again about the body's response to ideas of weight and weightlessness.

# The Magnificent Return of the Manga Superheroes of the Past

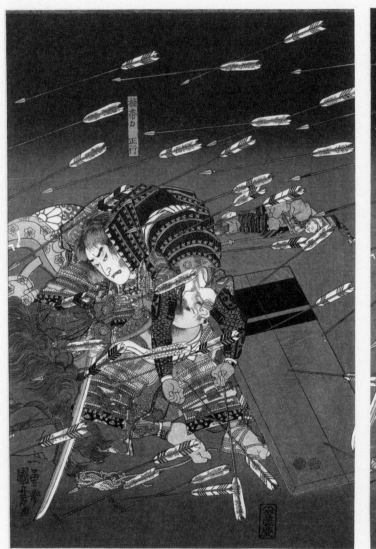

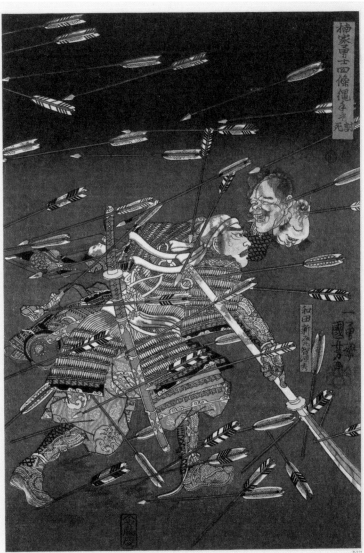

*Last Stand of the Kusunoki Heroes at Shijo-Nawate* (1851), Utagawa Kuniyoshi,
(l. to r.) 38 × 26.2 cm (15 × 10 ³/₈ in.); 38.2 × 25.7 cm (15 × 10 ¹/₈ in.); 38 × 25.8 cm (15 × 10 ¹/₈ in.),
British Museum, London

Great art can often seem quite cloistered, set apart in its
cultural loftiness, the stuff of museologists and finicky connoisseurs.
These feelings are often underpinned by the grave monumentality
of so many of the wonderful buildings in which much of this art is
displayed. They help us to walk tall amongst those who may know
just a little bit less than we do...

Not so this triptych of three Japanese woodblock prints from
the middle of the nineteenth century. What shocks us at first is its
vivid feeling of nowness and contemporaneity. It feels hectic, noisy,
pullulating with heady violence. Its essential visual rhythms enthral
us: that back-and-forth pushing of the three warriors as they fight
back against what seem to be near impossible odds. See how the arrows
of the unseen enemies teem leftward in great swooping, clattering
droves as the three pale-faced-almost-unto-death warriors – stare into
the ghastly blue pallor of their mask-like faces! – push rightward
in an ever more desperate effort to gain ground... Their burdens seem
near impossible.

The warrior in the vanguard of the three, Wada Shinbei Masatomo,
is carrying a couple of decapitated heads – the one we can see so clearly
is grinning even in death – swinging them out in front of him in a
gesture of defiance. Their leader, Kusunoki Masatsura, the last of the
three, pausing momentarily to lean against the corpse of a dead horse,
is labouring under the weight of a corpse sprawled across his back,
who may be the body of his fallen younger brother. That corpse helps
to shield him from the mighty, unstoppable spray of arrows. The
central figure is driving forward beneath the inadequate protection
of a woefully collapsing battle standard. Only the leader for the day

forges ahead, eyes in a kind of trance-like engagement with those of the enemy, as he shakes those heads like a brandished fist. This vivid evocation of a medieval battle – which can be dated very precisely to the year 1348 – almost smacks you in the face. Its cluttered liveliness, its pell-mell fury, its violently raucous disorder is so exhilarating to scrutinise in all its gorgeous decorative intricacy.

Can it really be the year 1851 when this print was made? There is a shocking immediacy about it. We feel that it belongs as much to our culture as to theirs, to these times as to those. We have been plunged into a world of superheroes of the present tricked out in the gorgeous apparel of times past – the warring samurai of ancient Japan.

Why does this image seem so vividly alive in the present though? In part, this is not too difficult to explain. The works of the enormously popular printmaker Kuniyoshi – and they had run into thousands of images by the year of his death – have fed into manga comics and much else. You could say that so much of what he made formed a part of the great legacy of what developed, closer to our times, into popular cartooning. Such images as these have dispersed – like these shooting arrows – throughout popular culture. They are in the air everywhere. They have also dispersed into such worlds as video-gaming. Even now such a battle scene as this one may be unfolding in your basement. Having said that, popular cartoonists seldom bless us with such fineness of detail. For all that, there is the same spirit of brash and colourful adventure, and the same ferociously simple message: kill or be killed.

Why was Kuniyoshi making such images at this time? This is one of many images he created of valiant battles against terrible odds, fought against human beings of other clans, giant carp or grisly spectres. Japan

itself – as a country, as a nation, as a preciously bejewelled fragment of cultural identity – was under threat as never before. Its centuries of proud isolation had been breached. Enemies – from Europe and elsewhere – were circling, battering at the gates. This image, you might say, was one of many popular attempts to re-assert a proud identity which was currently under threat.

Here are the majestic few – the three musketeers, you might say – pitted against the unseen hordes from without. What better way of stiffening the backbone of resolve than to remind his fellow Japanese of their great warrior heritage, to re-establish historic continuities?

Such a
Comical
Ramshackle
Beast – Pocked,
Weathered,
Pre-tannery...

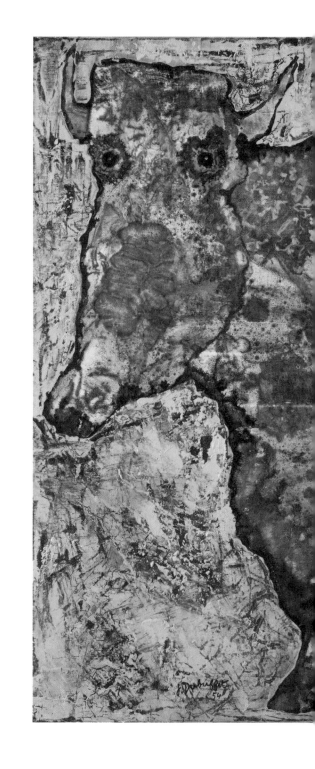

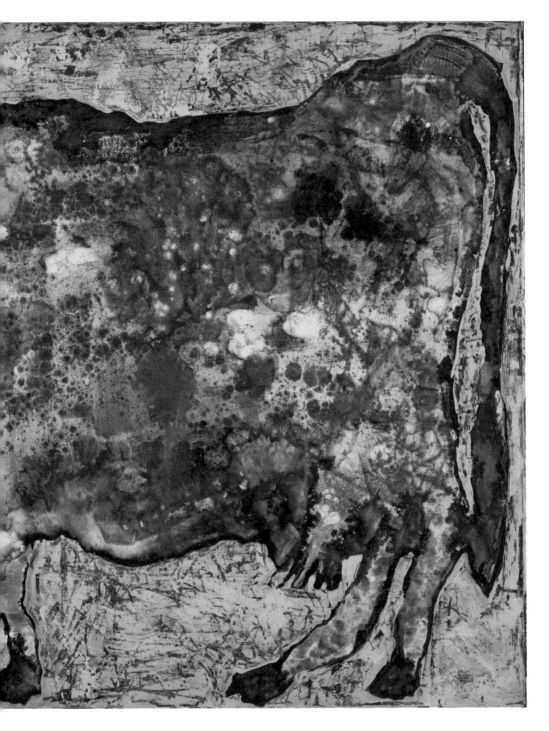

*The Cow with the Subtile Nose* (1954), Jean Dubuffet,
88.9 × 116.1 cm (35 × 45 ³/₄ in.), Museum of Modern Art, New York

How, casually ranging across the world's cultures, might we describe some of the characteristics of the cow? Try some of these possibilities, and ask yourself whether they make a good fit with your own assumptions about the nature of the beast and what it has come to symbolise. The essential benignity of the cow. The docility of the cow. The nobility of the cow. The untouchability of the cow. The ponderousness of the cow. The abundant fertility of the cow. The sacredness of the cow. The bucolic charm of the cow (in a landscape by Jacob Ruisdael or Aelbert Cuyp, for example, in which the animal, amidst all that gloriously soothing light, seems to embody the very meaning of the pastoral scene in which it sits, eternally slumped, by giving it a kind of timeless rootedness). Is that all?

Certainly not. Facing in quite a different direction, there comes, ambling along, udders gently swinging, this cow by Jean Dubuffet with the long, thinning and slightly skewed (could it have been broken and re-set?) nose. Is this not an example of the uproarious, no-holds-barred comedy of the cow? If so, it would be entirely at one with the practice of its maker. Jean Dubuffet, prosperous wine merchant turned painter in middle age, was a great champion of Art Brut – also known as Outsider Art. He amassed his own great collection, which was subsequently gifted to the city of Lausanne. Although not an outsider himself, he believed in – and embodied in his own work – the spirit of Outsider Art. Which is what exactly?

Outsider Art is essentially untutored art, art which seems to run counter to the rules of the academy. Most outsider artists are self-taught, and Outsider Art itself is often driven by a kind of unruly intuitive verve – call it madness of a kind if you like (not all the great outsider artists suffered from psychiatric disorders, but many of them did).

Is this cow mad then? Or is it merely naïve? It certainly seems to pose
a mighty threat to the idea of the cow as some grave, heavy, timeless
bearer of spiritual values. What then are this beast's characteristics?
Fundamentally, they are physical. Many cows are regarded, as we
have suggested above, as more than – or other than – physical. They
bear a spiritual weight. They embody sanctity. This is no such cow.
This is a ramshackle creature without a thought in its head, unstable
on its skidding back legs, more a skin stretched out, pocked, pitted,
weathered, pre-tannery, and almost nailed to all four corners of the
canvas, than a cow with a beating heart. Is this a childish view of a
cow then? The jitteriness of its drawn outline seems to suggest as much.
It looks flat, badly weathered, beaten about. It feels horribly contained
within this space, which is far too small for it. What is more, this is a
shocked creature. Look into its eyes. It was not expecting to be stared
at by you and you and you. It was not expecting to be characterised and
scrutinised in this way, the strange, cordillera-like bumps along its back,
the odd, scratchy, green surround within which it is contained.
Is this a field in which it stands? Has any field ever been green in the
way that this field is so pukily green? Could this stretch of green have
the temerity to call itself a field? Those eyes are ridiculous too, the
way they pop at us. They are raving eyes, raging eyes, eyes fresh out of
trauma – or perhaps still deep inside it. How did those eyes come by all
that pretty-girly blueness? How does that fit in with the idea of the cow?

And yet, for all that, we positively like this cow. Stripped of all
pretensions to be anything other than a lumbering animal, it is one
of us, we feel. So much washed up flotsam and jetsam like the rest of
us. Meat, surface area – in short, a thing that takes up space. Too much
space, you could say, within this cruelly straitened rectangle. It has no

other baggage. It does not come to us invested with symbolism at all. It does not trumpet itself. If it were invited to bellow, it might well bleat. It is stripped bare of nearly all that old-time cowish stuff. And why not laugh at a cow anyway? If we can laugh at the ridiculousness of ourselves in the mirror, why not laugh at a cow?

# Painting the Cold Currency of Those Democratic Lowlanders

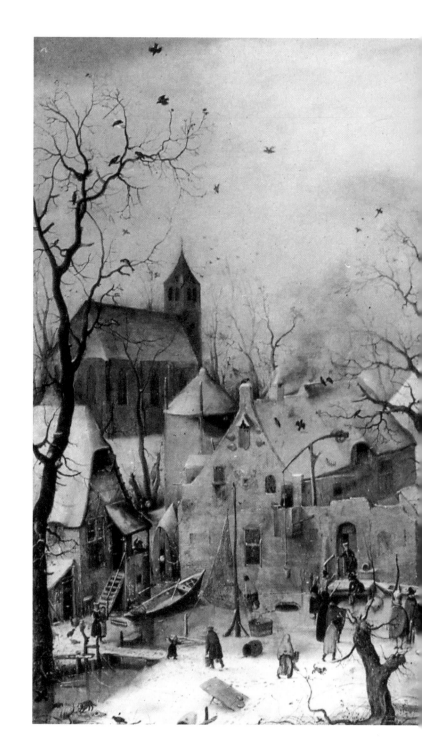

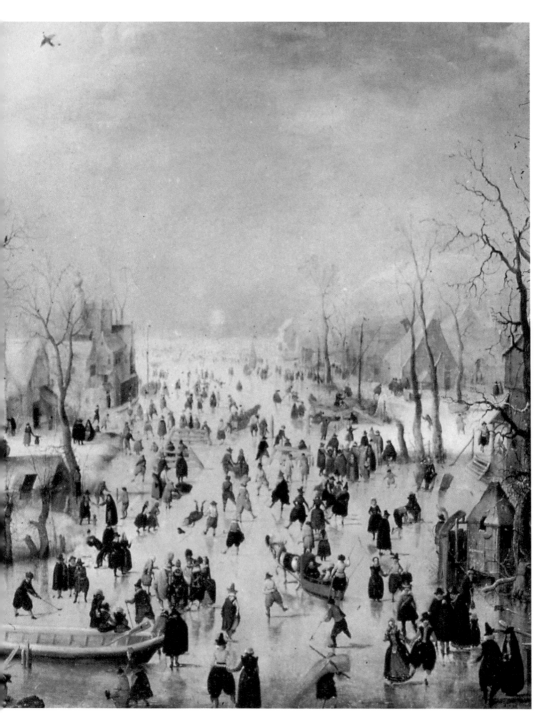

*Winter Landscape with Skaters* (c. 1608), Hendrick Avercamp,
78 × 132 cm (30 ¾ × 52 in.), Rijksmuseum, Amsterdam

Several important paintings from the Dutch Golden Age, of which *Winter Landscape with Skaters* (c. 1608) by Hendrick Avercamp is a particularly fine example, show us socially levelling, panoramic glimpses of a people going about its deep-locked winter business in thrillingly icy conditions. Dutch painting abounds in such celebratory winter scenes. What is more, skating in winter is as popular a pastime amongst the Dutch as it ever was – in the winter of 2008-09, for example, nearly one million pairs of ice skates were sold to a population of approximately sixteen and a half million. It was the sixteenth-century Flemish master Pieter Bruegel the Elder who had first established the winter scene as a legitimate subject for serious painters, and his treatment of the subject in such a celebrated painting as *Hunters in the Snow* (1565), with its high horizon line and its panoramic view across a mountainous landscape, would be copied again and again.

And so it is here in this painting by his junior admirer Avercamp, where we have an extraordinarily panoramic view of a village on the banks of a frozen canal. It feels as if the entire population, young, middling and old, is out of doors, enjoying the winter air, in the grip of ice fever. The scene positively teems with skaters. Some are playing; others are gliding along as they gently rock from side to side; yet others have taken a comic tumble. Almost everyone is on the move. You can almost hear the noise, the excitable commotion, of it all – which is interesting in itself because its painter was deaf, and during his lifetime he was known as 'The Mute'. The breadth of view from left to right and bottom to top seems to be enormous, with a sweeping, coppery-cum-roseate sky inhabited by birds which seem to be flinging themselves about in all directions – the gaiety of the birds, some perched

precariously on the wintery-skeletal branches of trees, mirrors the high spirits of the humans frolicking, skating and playing on the frozen surface of the canal.

It is a truly democratic scene, socially inclusive in content, upbeat in mood. We can almost sense that the rebellious Protestants of the Low Countries, under the leadership of William of Orange's son Maurice, are on the brink of throwing off (albeit temporarily) the shackles of Spanish domination in the rebellious northern provinces, though the conflict – an on-and-off war which dragged on for a scarcely credible eighty years – would not finally end until 1648. We also recognise from the subject matter of this work that painting is becoming a common cultural currency amongst the prosperous trading classes, that it is no longer the preserve of an aristocratic minority. This is the kind of painting that would be purchased for, and shown in, the houses of merchants.

Avercamp was back living in his native Amsterdam when he painted it, but one interesting detail may suggest that it was painted for an immigrant from the Southern Netherlands, of which there were so many in Amsterdam at this time. The coat of arms of the city of Antwerp (a double-headed eagle and the city wall, upheld by a brace of rampant lions) appears on the façade of the brewery in the left foreground of the painting. But there is something else which feels instinctively democratising (if that is not too high-flown a word) about this painting. There is no particular point at which the eye is being coaxed to come to rest. It has no focal point, no single eye to engage us, no flourishing head or magnificent rearing horse. We range and range about it, our own eyes in a perpetual swirling motion of

delight. Nothing is more important than anything else. A building is equal to a man, which is equal to the limb of a tree. There are no hierarchical highs and lows here. Ice is the great leveller. And this perpetual movement on our part is exactly what the painting seems to be expecting from us, we feel. It too is a rollicking, blaring scene in perpetual motion – we feel that we are lucky to have caught it at rest, tantalisingly arrested, for one split second. And yet it is more than a single moment of arrest. It is also a kind of summarising of every day spent on the ice, year after year. Nothing will ever change very much, even though the people will change.

This is the kind of painting which deserves the attention of the magnifying glass, to such an extent does it teem with anecdotal detail. It is a fashionable mirror held up to its times – as were so many of Avercamp's paintings and drawings – and a place to observe social customs of so many varieties. How, for example, did the Dutch keep themselves from starving during these long winter days? This painting provides one answer to that question. Look at that left-hand corner of the painting once again, letting your eye stray down from the coat of arms that we have already scrutinised. There you can see what looks like a large grey wooden door, propped up with a stick. A length of cord seems to be trickling its way away from it, almost surreptitiously, across the frozen ground. This is a bird trap – the cord ends at a window, at which a grasping hand and a keen eye will be waiting for a bird to be tempted into the trap, at which point the cord will be given a good yank, and the door will descend. These bird traps were relatively common sights in seventeenth-century Holland during these difficult winter days, and this particular trap is almost identical in appearance to the trap which Pieter Bruegel the Elder depicted in *Winter Landscape with Skaters and a Bird Trap*, painted forty-odd years before his disciple

Avercamp dusted off the motif. In spite of the fact that it is facing in a slightly different direction, it is virtually that same grey, bird-hoodwinking door. And what human on earth does not love a serviceable old door?

# A
# Masterful
# Sampling
# of History
# in the
# Making

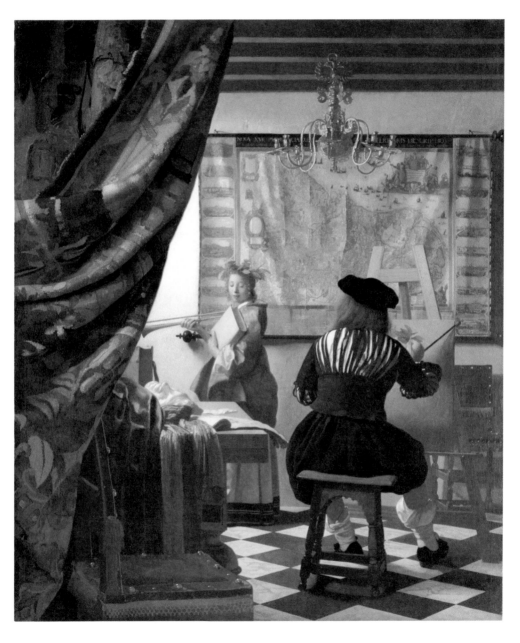

*The Art of Painting* (c. 1666–67), Johannes Vermeer,
120 × 100 cm (47 ¼ × 39 ⅝ in.), Kunsthistorisches Museum, Vienna

In its making, this painting is utterly characteristic of the mature Vermeer: admire the warmth and the moistness, if not the butteriness, of the light; the different weight and tactile force of the colours, shifting from soft and yielding through to hard-edged; the lovely, almost seemingly effortless, manipulation of perspective; and the way he has organised objects and people within the space of the painting – to such an extent that what we are looking at almost has an air of inevitability about it. And yet it offers a little something extra too, this painting, something we meet less frequently in this artist's work. Is there not just a gentle touch of self-conscious panache, and even of swagger, in that title, which causes us both to look at what is in front of our eyes – and go on looking and looking at this inexhaustible scene – and to step back and admit to ourselves that this is both a painting and a reflection upon what the art of painting, when practised at this level of achievement, actually consists of, what the art of illusionism – and what the art of history painting, that most exalted of genres – really means?

It is several paintings in one then. It is both a rather touching domestic scene with a tiny, wheedling underground stream of eroticism (look at the painter's raring red hose, and admire his bulking, almost bull-like presence when seen from behind) and a history painting, executed at a very significant moment in the history of the young Dutch Republic, which poses as an allegory of some importance. It is a third thing too. It is a painting of our witness to the making of such a painting. We are spectators, are we not, in this impromptu studio? The tapestry has just been yanked aside to admit us to this rather private scene, which enables us to observe a painter who is creating a history painting. We are also seeing much more than this though.

We privileged viewers are observing the entire context in which this painter is working, so you could say that the theme within a theme – the making of a history painting whose subject matter is Clio, the Muse of History, which we just about glimpse beginning to emerge on the painter's canvas – is only a part of this painting's whole. Yes, we are being treated to a scene which encompasses the making of a history painting, but the history-painting-in-the-making whose creation we are witnessing is much less than the painting we are staring at. Much will be absent from that small scene. That scene will not, for example, take in most of the map, which alludes to the liberation of the northern provinces from Spanish domination. This was relatively new history when Vermeer was painting this scene. Neither will it encompass that chandelier, with its twin Hapsburg-like eagles – yet another pointed historical allusion. See what those Hapsburgs have been reduced to these days, those eagles seem to say to us. Are they not as swingeingly powerful as decorative details on a chandelier? So *our* history painting – as opposed to the one which has been commissioned from this painter with his back to us – is much fuller and more pleasingly detailed than this representation of Clio herself is ever likely to be.

So, thematically speaking, this painting is both large and small – or, depending upon your point of view, large and yet larger still, because small paintings can be very large indeed. It is a lovely and quite intimate domestic scene, with a touchingly gauche and shy young lady – admire the downturn of those eyes – tricked out to represent a personage as significant as Clio. Look at her laurel crown, balanced just a touch precariously (we see it again, as if to emphasise its importance, as we peer over the painter's shoulder), the trumpet that she clasps in her right hand, and that almost comically unwieldy book. The painting is not finished, of course. It will never be finished. History – like a painting – is only ever in the making.

# An Apotheosis of the Spirit of the Pumpkin

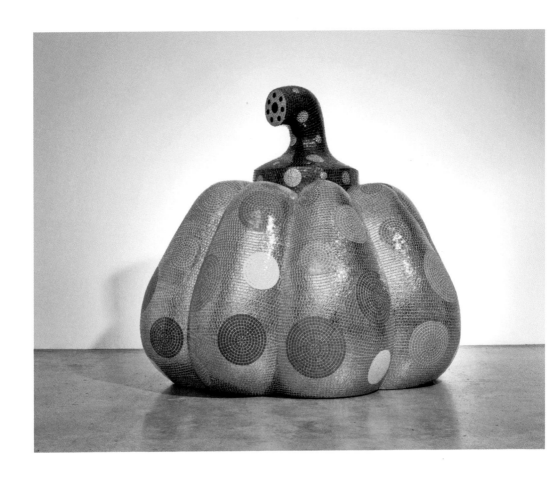

*Starry Pumpkin Gold* (2014), Yayoi Kusama,
182 × 214 × 214 cm (71 $^5/_8$ × 84 $^1/_4$ × 84 $^1/_4$ in.), Victoria Miro Gallery, London

There is something outrageous, boundless, almost unstoppable about the art and the person of Yayoi Kusama. For once it is sensible to couple art and autobiography because in her case, as in few others to quite this extent, the two are one. Drawing and making, from her earliest childhood in Matsumoto City, have enabled Kusama to survive as a sentient being. Her art has defined her, given her stability, and a reason for being. She has lived as a willing slave to her own artistic impulses. And of all the motifs to which she has devoted her attention, pumpkins have been amongst the most significant.

Here is how in her autobiography she described communing with pumpkins during her teenage years, when she was living in a house on a mountainside in Kyoto owned by a haiku poet and his family:

> My room was on the upper floor, and that is where I painted relentlessly realistic pictures of pumpkins. Before dawn I would spread a sheet of vellum paper on top of the red carpet, line up my brushes, and then sit in Zen meditation. When the sun came up over Mount Higashiyama, I would confront the spirit of the pumpkin, forgetting everything else and concentrating my mind entirely upon the form before me. Just as Bodhidharma spent ten years facing a stone wall, I spent as much as a month facing a single pumpkin. I regretted even having to take time to sleep.

The obsession took root, and then continued life-long. The pumpkin's appeal was in part to do with the fact that it was so often unloved and uncared for – was not the term 'pumpkin head' habitually used to describe ugly people? Kusama took a quite contrary stand:

pumpkins deserved to be raised up and set apart for our delectation because of their solid, dependable, unpretentious earthiness.

Then, well into her ninth decade, she fabricated the giant pumpkin you can see here which, in its tremendous, floor-grounded presence, seems almost like an apotheosis of that idea of the pumpkin which she drew as a teenager with mineral pigments applied to paper or silk. And yet this is also a pumpkin transformed. It is not tender and yielding – that is how she first regarded them. Now it is bold, and almost defiant, in its glittering presence. The form of the pumpkin has been simplified and rendered regular – as if to suggest that it is somehow the distillation or the perfection of pumpkin-ness. It reminds us, in all its puffed-forth, gold-tiled lustrousness, of a reliquary or some other object of profound religious significance. The circles of colour which punctuate its surface add just a touch of free-wheeling carnival, as if it also exists to lift the spirit. They also remind us of those first dot paintings that she showed as a young artist in New York City in 1958, and of the significance of those dots to her life-long: 'my desire was to predict and measure the infinity of the unbounded universe, from my own position in it, with dots,' as she expressed it in *Infinity Net*. And yet, as we meditate upon this glistering pumpkin, sitting there, so ponderous on its surface, so plumply segmented, we recognise that it is also entirely rooted in its humbleness as a mere vegetable.

# The
# Pendulum
# Swings
# from Age
# to Youth

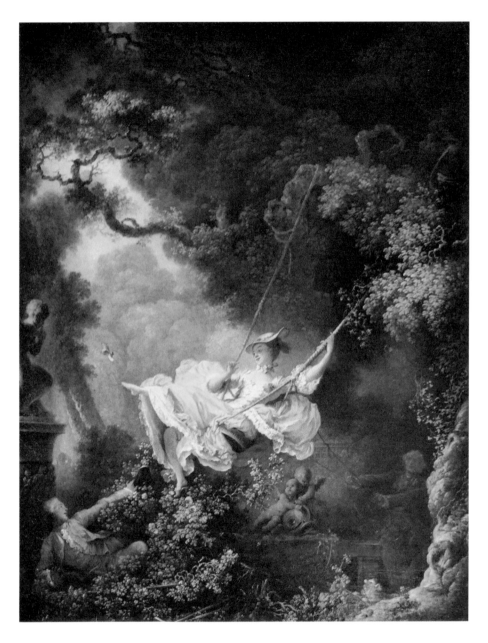

*The Swing* (c. 1767), Jean-Honoré Fragonard,
81 × 64.2 cm (31 ⁷/₈ × 25 ¹/₄ in.), Wallace Collection, London

Some paintings live in homes perfectly tailored to their moods. This piece of toothsome frippery from the seventh decade of the eighteenth century, painted by a Frenchman who just loved to show off, occupies wall space in the Oval Drawing Room of the Wallace Collection in London, an intimate blue interior once used by the 2nd Marchioness of Hertford as a ballroom and, more generally, a place to entertain. The paintings on the walls, many of them by Fragonard's teacher François Boucher, are airy and delightfully preposterous. Some of them are little better than puff balls which deserve to be glanced at side-on as one gets on with the more serious matter of cracking a good joke or two and perhaps, simultaneously, turning out a well-hosed leg at the ladies.

And yet something else needs to be said. This kind of thing can be done well or badly, and here Fragonard does it with great panache. Nor is the painting quite as simple as it seems. Is it about libertinism alone, that wish to live in a Sadean zone entirely beyond the dictates of public or private morality? In 2004, Yinka Shonibare exhibited a three-dimensional, ruthlessly pared-back version of this work at Tate Britain in London. Most of the abundant foliage was stripped away. The two men who play such an important role in the original painting were absent, and the coquette in the swing headless. The message was crystal-clear: beneath the mask of erotic and air-headed frivolity, there were deeper and darker stains of misrule which many members of the frivolous ruling classes of France would need to account for in due course in the presence of the guillotine.

Was that interpretation too simple by half? There is a fairly familiar view of the game that is being played here. An old man controls the

flight of a swing which holds his young lover. The more he pulls back on the twin ropes and then releases, the more revealingly does she kick her legs out at a much younger pretender concealed in the bushes, who gazes up at her gracious undergarments in slavering wonderment. Even her slipper, which wheels, turning, through the air, has come adrift. That slipper appears to be moving in the direction of a statue of Cupid on a plinth, who has his finger to his lips, shushing her.

So it is all about concealment and roguish dalliance, with an old man duped – as ugly old men sometimes tend to be.

Yet this is not quite so, we are inclined to add. There is a moral tale here too, and it runs as follows: the pendulum swings from youth to age and back again. The swing is Time itself, which perpetually offers up to the young what old age fades away from. There is an air of inevitability about it all – youth will almost always seek out youth. Age must cede to youth. That is the way the world spins. And the girl dallies in the air between, lit like some angel.

There is something else about this painting too, its pastoral setting, which suggests that Fragonard may have created something generic. This is quite untrue. The visionary intensity with which these trees are painted – look at the magnificent specimens at the back of the painting, billowing as mistily as storm clouds – recalls the greatness of Poussin, the most accomplished painter of trees who ever lived. The trees are electrifying, yet Fragonard has lifted the coquette up and out by lighting her in such a way that she seems to be almost naughtily angelic.

# Mystery
# Heaped
# upon
# Mystery

*Landscape with the Fall of Icarus* (1554–55), Pieter Bruegel the Elder,
73.5 × 112 cm (28 ⁷/₈ × 44 ¹/₈ in.), Royal Museum of Fine Arts of Belgium, Brussels

It is easy to fall a victim to the urge to pigeon-hole. It makes us feel comfortable. Life has assumed some kind of order. Some paintings resist that urge because, well, the life of paintings, finally, is often ungraspable, wayward and tumultuous. Such paintings remain, in many respects, unfathomable mysteries. This is a painting of that kind. And, as if to add to its appeal, it is by a painter of rollicking, tankard-clashing Netherlandish rural life that we think we know so well...

Is this landscape, seascape or something else? Is its primary aim to depict a time-honoured instance of rustic toil, set perhaps in the ploughing months or May or June, in the sweet falling light of evening? After all, it is the colourfully blouson-ed ploughman, both sleeves billowing and blazing, teetering forward rather balletically in his clogs, who arrests our attention. And then, as our eyes stray beyond and behind, the mood appears to shift. Those billowing sails at his back seem to turn this into a scene of forward-surging promise, as if all life is ahead of us: the life lived, for example, in that glitteringly distant fabled town on the bay...

And yet for all that appetite-whetting promise of fabulous distances, is it not still the homely ploughman who is solidly at the centre of things here, with the shepherd boy at his back who stares at the sky? That is what happens in these parts: the land is tilled; a boy stares at the sky; time moves, in its ever turning cycles. And yet that also is not quite true. There is much more to admire and puzzle over here than rows of furrows, cleanly cut as lengths of carpeting, or self-preening sailing boats.

Yes, there is what is happening in the middle and at the back of the canvas, and then there is what is happening just off to the side too, which proves to be something highly insignificantly significant: that

pair of kicking legs, which appear to be both waving – if legs can be said to wave – and drowning, seriocomically. Whose legs are these anyway? The title tells us.

Let us try entering this painting by the side door of a poem. During the winter of 1938, W.H. Auden wrote a great poem with a boring title about this great work of Bruegel's called 'Le Musée des Beaux Arts'. Auden's poem turns the painting into a kind of homily in praise of the wisdom of an old master because he has noticed that the truly significant act in it, that which raises it from a painting about rural life to one which engages with ancient myth, is given laughably little attention. But quite deliberately so, says Auden, because the really important things of life happen in corners, where people are disinclined to look.

What exactly has happened then in this corner of the sea? That pair of legs is kicking out, wildly. Someone is drowning. Above those legs, feathers float in the air. Who is this boy? It is Icarus, the son of Daedalus, who is being punished for his recklessness. Icarus has mounted the sky, borne up on wings fabricated by his father, but he has failed to take into account the fact that the sun's heat, at a certain point in his journey, will melt his feathers and cause him to go tumbling seaward to certain death. The hubris of the boy is punished. That is Bruegel's message to us – perhaps. I say perhaps because this explanation fails to take account of a dagger on a rock and a corpse in a coppice. Oh dear. Mystery heaped upon mystery.

# Deaths
# by
# Anonymity

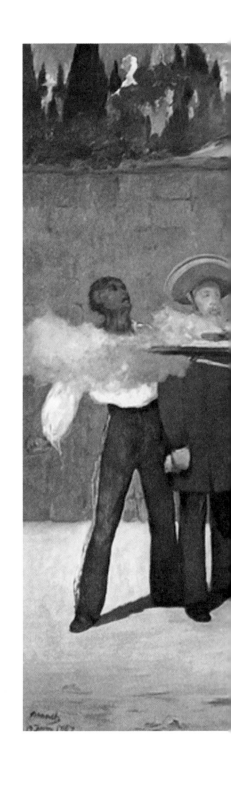

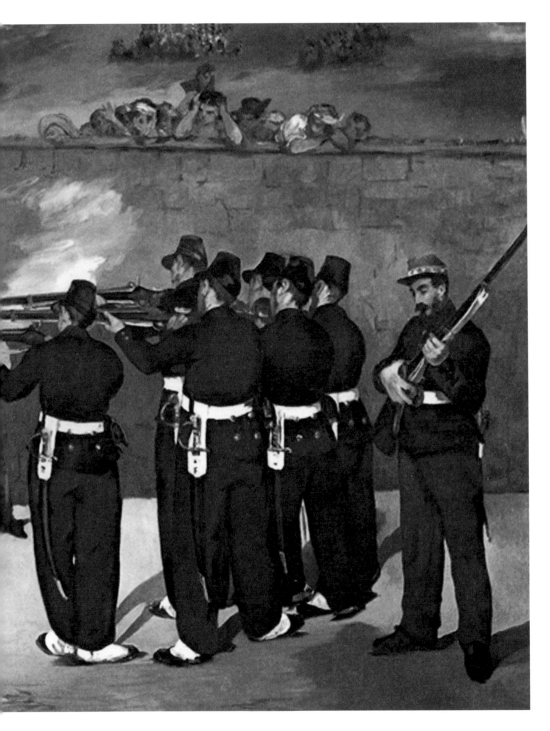

*The Execution of Emperor Maximilian* (1867), Edouard Manet,
196 × 259.5 cm (77 ¹/₈ × 102 ¹/₈ in.), Museum of Fine Arts, Boston

A lack of finish in a painting troubles us. It can also exhilarate, opening up various interpretative possibilities which are never quite realised. This painting exists in three versions. One is in Boston, another in London, and a third in Mannheim. Two of these versions are either fragmentary or incomplete. The third is finished, but the almost polished representation of the story that it tells falls short of giving us much imaginative satisfaction. Manet, in that final version, has shown us too much. It is too finically perfected in its execution. And yet Manet drove himself on to do it, to bring it to a successful conclusion in the way that he did.

Why? Because he was striving to rise to a very particular occasion, which was the depiction of a subject of great public importance – the killing of an emperor and his two generals by firing squad. It was the kind of picture that would surely make his name at the Paris Salon. Alas, the Salon rejected it even before it was officially entered. Manet would never become the history painter he perhaps only half-wanted to be.

The first version of the three – which is the one you can see here – feels the most urgently alive. It has the stink of reality about it for all the fact that it looks a bit rough and ready in its execution. There is a clutter of bodies here. Nothing is orderly or especially well managed. The soldiers feel nervily close-packed. We can smell the stink of all that rising smoke after the collective discharge of those firearms. The fug that hangs above the scene resembles an old-time London smog.

These problems – a sense of sketchiness, hurry and even unclarity – were unavoidable. They also explain why he never finished the painting. Manet was struggling to keep up with the present. He was painting

it as news of the assassination was reaching him through the press. He had to remain faithful to the reported details as they came in. Unfortunately, some of these so-called facts were then contradicted by further so-called facts. Such are the difficulties presented to an artist when he tries his hand at making a painting which is also a timely documentary.

The subject was politically controversial. Maximilian, sometime emperor of Mexico, had been executed on the orders of the man who supplanted him. Napoleon III of France – a man heartily disliked by Manet – was in part to blame for the emperor's vulnerability. He had withdrawn French troops from the country, leaving him naked in the face of aggression.

Manet found himself hugely drawn to the subject when he first read about it in a newspaper in July 1867. He had recently seen Goya's *The Third of May* at the Prado in Madrid, another great painting about a public execution by firing squad – and he felt a need to respond to this new atrocity. But, as mentioned, he felt hobbled by a lack of accurate information. What exactly were these solders wearing? First, guessing, he painted them in sombreros, only to discover a little later that they had in fact worn *kepis* as headgear – which is why there is a mixture of the two here. The three men who are being executed are featureless – the general to the left of the emperor himself appears to be wearing a black hood, thus guaranteeing anonymity. They are featureless because Manet had no idea what they looked like.

And yet this featurelessness seems to work. It makes our pulses race. There is something chillingly effective about this hoodedness, this blanking out. It seems to speak for – and to appeal to – us all.

It seems to summarise the terrible, sudden, wholly indiscriminate – and perhaps wholly unjust – onset of suffering. By comparison, the faces of the three men in the final version of the painting, so docile, so blandly puppet-like, go to their deaths woodenly. We do not find ourselves reaching out and suffering with them. Manet knew too much about them by then. He no longer had the space to do a bit of feverishly anxious dreaming. The careful examination of a photograph or two had part-snuffed out all that inward terror.

# The
# Bold-Breasted
# Dominatrix
# Strides Forth

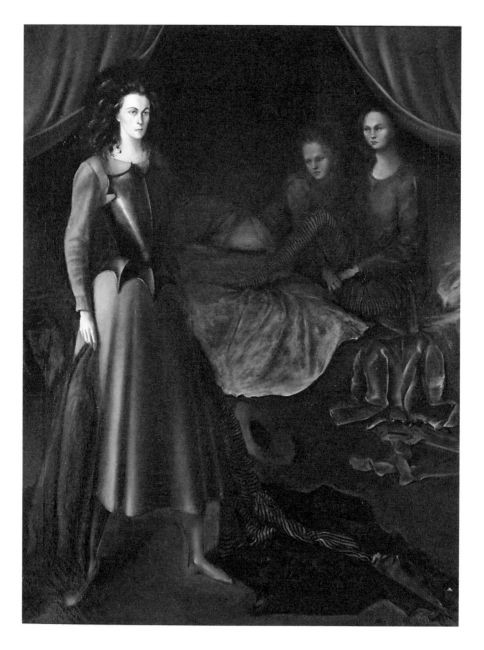

*The Alcove: An Interior with Three Figures* (1939),
Léonor Fini, 103 × 84 cm (40 ¹/₂ × 33 ¹/₈ in.),
Edward James Foundation, West Dean, West Sussex, United Kingdom

The overbearingly dictatorial presence of André Breton at the heart of the Surrealist movement – he regarded himself as its chief spokesman and principal theorist – can easily cause us to blunder twice over. We assume that it was essentially a French movement from first to last, with its nerve centre in Paris. This is simply not the case. Surrealism quickly became – and remains so to this day – an international phenomenon. (It is very much alive and kicking on the West Coast of America, for example.) Breton's loud-hailing presence can also easily tempt us into ignoring or underplaying the importance of the many female artists in its ranks, for whom it was often a way of exploring issues of gender, identity and much else. Female artists, for example, were well represented in the very first International Surrealist Exhibition in London, which took place at New Burlington Galleries in the summer of 1936. That was the occasion on which the mercurial Salvador Dali came close to asphyxiating himself in a diving suit. A young English poet called David Gascoyne came to his rescue with a spanner.

Why was Surrealism so important to female artists? The idea of the unconscious is a social leveller. The acceptance of the reality of the world of the dream as an indicator of truth-telling threw open to women new possibilities of play, anarchy and dramatic self-invention. Here, in this sombrely arresting early painting by the part-Argentinian artist and illustrator Léonor Fini, painted in the year that she had her first solo exhibition at the Julien Levy Gallery in New York, we witness role-playing and a certain alluring slipperiness when it comes to the defining of gender.

In part, it is a portrait of one female Surrealist by another – it was not at all uncommon for female Surrealists to scrutinise each other's

identity in this way. Fini photographed Dora Maar very provocatively, in 1936, black cat nuzzling between her parted legs.

In this painting, Fini herself is in shadow at back right, her head nudging up against one of a pair of green curtains, which have opened up as if to reveal some dramatic stage performance. The imposingly statuesque presence of fellow Surrealist Dora Carrington, auburn hair swept back off her face, red legs defiantly, provocatively, splayed, magnificently elongated, is poised to stride across towards us. She is the coolly impassive dominatrix of the inscrutable gaze, mistress of all that she surveys. Her curious costuming includes what looks like a bizarrely gleaming breast plate, which manages to look both metallic and leathery. Its nasty jaggings remind us of some diabolical detail that we might have glimpsed in a painting by Hieronymus Bosch. Is she the protector and defender of women? Or is this an erotic aid? At her back, almost engulfed in shadow, are Fini, whose raised leg writhes out like some insect's, and, beside her, leaning in as if in fear at what she is seeing, her androgynous companion, whose body, naked flesh partially exposed to view, seems to be so awkwardly twisted. Garments, streamings of fabric, slither away into the shadows. It is a strangely absorbing, sexually charged scene.

# Sweetly Tweaked Creature, No Sooner Blown but Blasted

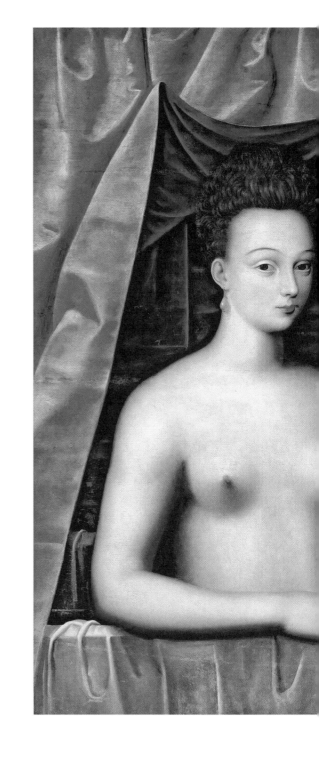

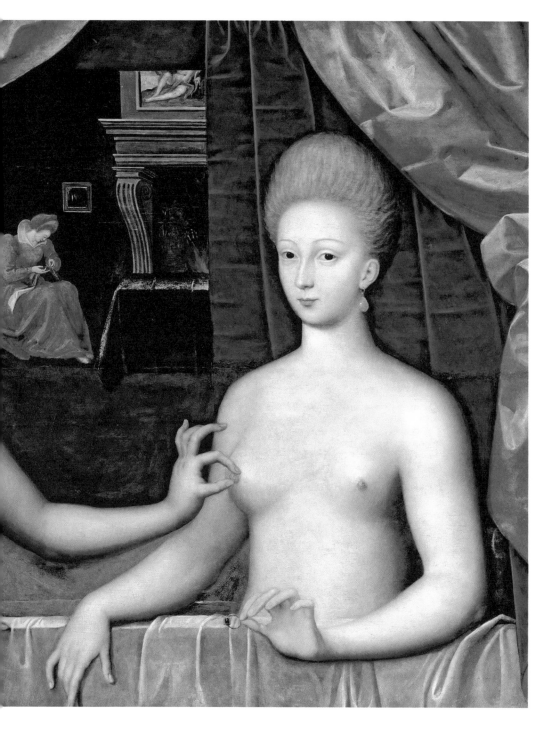

*Gabrielle d'Estrées and One of Her Sisters* (c. 1594), unknown artist,
96 × 125 cm (37 ¹/₄ × 49 ¹/₄ in.), Musée du Louvre, Paris

Ouch, you tweaked my tender nipple, my once so dear sister!
Has such a mysterious, erotically charged act as this one ever been
represented quite so coolly, quite so finically, quite so clinically, and
with quite this degree of inexplicable reserve or perhaps even *froideur*?
It is all so very delicately staged, as if the entire scene is not so much being
lived through by its two lovely protagonists as enacted, or re-enacted,
in order to bring the gesture to some degree of formal perfection. It is all
so lightly peppered with that necessary modicum of poise and decorum.

There is such an air of courtly seemliness here, from the beautiful
bee-hive coiffing of the hair, to the perfect arcing of the eyebrows, from
the made-up lips, to the lovely, water-droplet-like ear pendants, that
were we considering the heads alone, we could easily imagine ourselves
to be present at some formal presentation. Not so. This is a very fine
and private place, which is only *pretending* to be public. After all, these
women are naked. Neither woman is paying any attention to what
the surprised onlooker is gawping at so wonderingly. The hand which
tweaks seems to have found its target without even looking in that
direction. Neither face registers the faintest flicker of emotion.

In fact, the entire scene, with the two young women in their bath
at stage front, a bath slightly disguised (and perhaps made less cold to
the touch of naked flesh) by a cloth, and the older and more respectable
chambermaid busy with her sewing (in fact, curiously indifferent to
everything but that sewing) at stage rear, looks like a got up theatre set,
with the heavy swags of red curtaining, even as we seem to chance upon
the private nature of the scene, drawing apart in order to reveal this
unusual element of erotic play. The two naked bodies emerge, looking
so fruitful, from all this darkness and domestic probity, skins lusciously
glowing a pale ivory.

Two acts of tweaking are going on here, one involving a nipple and the other a ring. What is the relationship between these two acts of pinching? It is scarcely credible that the painter had no mind to suggest one. In order to answer that question, we need to know a little of the painting's backstory, that, for example, the woman on the right was the king's mistress, who also happened to be pregnant. This young woman was called Gabrielle d'Estrées, and she was to bear Henri IV of France three illegitimate children before the likelihood of betrothal hove into view. And here she is, in the flower of her first pregnancy – although there is really little evidence of that pregnancy from what we can see of her bodily shape. No, the proof of the pregnancy lies in her sister's brazen gesture. That sweet nipple, it seems to be saying, will be transformed into a suckling pap in no time at all. Is the ring which Gabrielle tweaks an earnest of their future marriage then?

Alas, all was not to go well after all. Death swept her off her feet when she was barely twenty-five years of age. Sweet creature, no sooner blown but blasted, as some court poet might have been found murmuring, from the wings.

# The Sweet,
# Self-Delighting
# Floatingness
# of It All

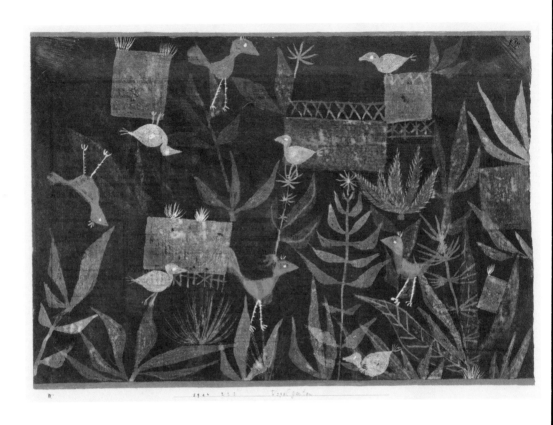

*Bird Garden* (1924), Paul Klee,
27 × 39 cm (10 ⁵/₈ × 15 ³/₈ in.), Pinakothek der Moderne, Munich

There is something utterly self-sufficient about much of the world of Paul Klee. Once inside it, and having shut the door on the hubbub of misery and awkwardness just beyond its tiny perimeters (yes, you would be hard pushed to find a large work by Klee), you feel perfectly at ease in its company. It offers us a kind of lightsome alternative, perpetually self-delighting – and delighting us too. It does not feel solipsistic in the least. It is tangentially related to the world in which we all live, move and have our being, but it is also utterly set apart from it. Living in parallel, you might say. In part, it is a world of childish guilelessness, but then again it is not because we also sense how immensely calculated it all is.

Klee was no untutored boy. He worked for years as a professor at the Bauhaus. In fact, it would be true to say that Klee was a gaunt, serious, besuited grown child, we see that from many of the photographs of him, and that discovery rather surprises us. Klee has thought long and hard about botany, the laws of gravity and other serious matters, and then, quite deliberately, he has set them aside to do something quite different – or to do something as a kind of alternative commentary to the rules of things as we imagine them. He has gently set aside the reality of the world as we see it.

This lovely, fantastic, absurdly comic garden scene is as much music as painting. We feel that on our pulses as we look at it. Its lovely incongruities provoke delight. Each of those brash, small birds, so perkily self-assured, sounds like a single brazen struck note, usually quite a high note because they are treading very delicately upon the tops of all the leaves and all the plants. Not one of them is making

any impression upon these plants, many quite gorgeously sculpted, or on these leaves either. They are too light and too weightless to do any damage. In fact, they are so thin and light and dancingly papery-airy, so close to a kind of blowaway nothingness, that we notice, if we look carefully, that we can see right through them to the newsprint on top of which they have been magically painted into being. Not one of them is flying. They have no such ambitions. They are perfectly, harmoniously at rest here, picking their delicate way back and forth, round and round, across the tops of equally fragile and delicate natural things. Nothing bends beneath their relative weightlessness. They walk on longish legs which look like thin sticks of carefully buntinged and tagged Blackpool rock. They are walkers or standers to a man (or a girl).

In its totality, the music of this piece resembles that of a musical box, with the pleasing circularity of that clever, always beguiling device, the way the tune insists upon going round and round and round until you almost fall asleep, spell-bound, as you listen. This picture too, though it is rectangular in shape and, though small, a little larger than we really expect it to be (it has the look of a miniature), feels as if it is endlessly circling. Yes, the picture is in motion, comic motion of a kind, but it is also utterly frozen. It looks a little like a frieze, never to be changed or disturbed in its delicately attuned artfulness. Tonally, it is also very strange. Its murky, earthy greens make it feel almost aquatic. There is more than a hint of swimming here, and the kind of swivelly, darty movements that we expect of fish. It promises to be deep to look into — we want to look in, quite far — but our wishes are thwarted. The garden itself is, of course, pure artifice. It is a kind of prototypical paradisal scene.

There is human intervention here too, architectural details of a rather lovely kind, bits of lattice work across the top (or along the

bottom) of fragments of floating, wall-like structure – yes, even the illusion of a wall is robbed of its yearning towards solidity. These walls are slightly on the tilt, as if dreamily nodding off. The shapes of the leaves are leaf-shaped, but also not quite so. They are leaves which have been crisply scissored into form, quite extravagantly beautifully. They too, like the birds, are also permeable. When they overlap, we can often look through them.

This world of Klee's has removed all the tetherings, and we feel ourselves floating with it. The fact that at least one of these birds is walking upside down makes us feel that at any moment this painting could spin away from us, at first rather slowly. And when that happens, we will surely feel ourselves rather inclined to take flight too.

Thank you for the invitation, Mr Klee.

# In Praise of the Modesty of Well-Made, Painted Things

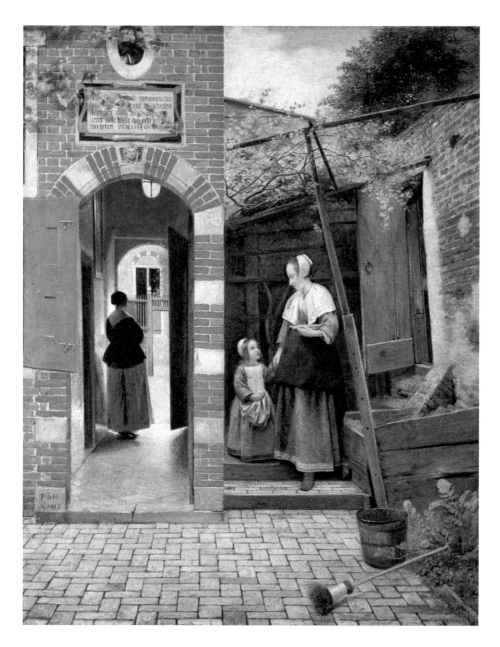

*The Courtyard of a House in Delft* (1658), Pieter de Hooch,
73.5 × 60 cm (28 ⁷/₈ × 23 ⁵/₈ in.), National Gallery, London

The sheer, unsurpassed ordinariness of it all (in what may well have been a wholly manufactured scene of a house's inner courtyard in the new Dutch Republic) is what quite takes our breath away. How many painters have lingered so long over the visual riches of bricks and mortar; have loved stains, smudgings, nails quite to this degree? And the work is cunningly placed too, in a far corner of Room 25 in London's National Gallery, a relatively small and unassuming spot, somewhat akin, in its feel, dimensions and general décor, to the parlour of a fairly modest though well-to-do house. And this, too, is quite appropriate – to this and other paintings in the same room – because so many of the great works of the so-called Dutch Golden Age were modest affairs in terms of both scale and subject matter: Vermeer lingers over a girl tinkling at the virginal; in another painting, dogs scamper in a kitchen as a cocky, rampant poseur sweeps off his floppy, velvet, Quangle Wanglish hat to a not-so-coy maid.

We ask ourselves: where exactly should our primary focus of interest be here? The answer is slightly perplexing: everywhere. The eye roams around, ceaselessly, alighting, and then setting off again on its never-ending tour. Our interest is evenly distributed across the entire surface. Why? Because nothing here seeks to outdo or to outshine anything else. Once again, this reminds us of what paintings meant to those Lowlanders at that historical moment. They were produced in quantity, and they were sold to adorn the houses of prosperous merchants – Vermeer's father was a dealer in paintings. He sold them from his tavern. This had nothing to do with church patronage or self-aggrandising aristocratic need. So there is an element of democratisation at work here. These were greatly valued, common

things, to be hung in houses, and they existed to show off the brilliance of the everyday.

This is a poem in praise of the solidity of well-made things, from the wooden pail to the broom, from the tiling of the courtyard itself to that lovely leaning espalier. Is it a moralising piece at all? We ask ourselves that because the inscription above the door – which still exists, though now it is inside a private house – speaks about St Jerome, and the need to show patience and meekness. Does this turn the scene into a homily of sorts? Various critics have thought so, and in the hands of a Victorian painter, this would surely have been the case. Not necessarily here though. De Hooch may not be praising the modest virtues of the young lady with her platter who tends to the needs of the child. The fact is that the inscription itself has been wrested from a monastery, and it is overgrown with ivy. It is something ancient, snatched from oblivion. Nothing more than that. What is more important is the mistress, staring out, turned away from us. She is busy watching time pass.

# The
# Infinite
# Patience
# of the
# Unlovely
# Collaborator

*Madame Cézanne in a Red Armchair* (c. 1877), Paul Cézanne,
72.5 × 56 cm (28 ¹/₂ × 22 in.), Museum of Fine Arts, Boston

Cézanne's many portraits and drawings of his wife Hortense Fiquet, painted over a period of about twenty years, were amongst the least known of his paintings during his own lifetime, and when they were eventually put on public display, the critics often responded with a combination of horror, bemusement, indignation and savage humour. Even his dealer, Ambroise Vollard, when showing several of them together in Paris in 1895, jocularly invited the connoisseurs to decide for themselves whether these works were masterpieces or monstrosities.

In fact, they were all painstaking experiments in the tortoise-speed advance of one modernist artist's singular vision, to which the ever dependable Madame Cézanne repeatedly subjected herself with an infinity of patience. Quite how intimate were these two though? It is impossible to say. They first met in 1869, but they did not marry until seventeen years later. Their liaison was a game of subterfuge. They kept separate establishments, and Cézanne hid the fact of her presence in his life for years. He feared losing the allowance that his rigidly moralistic banker father would surely have withdrawn from him had he known that his ceaselessly peripatetic son was in a relationship with the daughter of a mere farmer...

Cézanne the painter was slow, painstaking, secretive – no one was ever allowed to observe him as he painted. What did he actually feel about his subject? we cannot but ask ourselves. Was she more than a mere prop? Is there evidence of tenderness here? The woman was undeniably square-jawed and unlovely, and the critics shouted that out from the rooftops. What is more, she seldom seems to engage with the painter in any of these portraits. She is there for him to test himself against. Perhaps we can call her more a kind of mute, uncomplaining

collaborator than a sitter of the more conventional kind. The look is often, as here, askance, waywardly elsewhere, the eyes slightly crossed, the hair tightly pinned back. The face is leaden, almost humourless, as if constructed from individual facetings – more like one of Cezanne's painted apples than a human face. There is no evident animation here. And yet nor does there need to be because this is a brilliant exercise in merger and harmonious tonal chimings. Taches of blue and green rhyme with the blues and the greens of her glorious silk skirt. Everywhere colour responds to colour. What we feel most of all is that she has been subsumed into a sheer panache of decorative effects, and that it is perhaps the red armchair containing her, the spreading, plumping flourish of it at her back, which is the real heroine of the piece. By comparison with that skirt – which is almost as broad at its hemline as the breadth of the canvas itself – and that armchair, the face seems surprisingly small and under-emphasised. In fact, it has stepped back. Were it not also monumentally present, we might even say that it had almost gone away. And yet Hortense Fiquet never went away.

# The
# Banker's
# Act of
# Worshipful
# Extravagance

*The Adoration of the Magi* (1423), Gentile da Fabriano,
300 × 282 cm (118 1/8 × 111 in.), Uffizi Gallery, Florence

We cannot help but feel that there is a gloriously delightful conceit at the heart of this great painting. It was commissioned by an immensely wealthy Florentine banker called Palla Strozzi from an itinerant Italian artist who was practising on the cusp between Late Gothic and Early Renaissance. You can almost regard it as a glorious flourish of decorative exuberance in the Gothic manner.

What is of redeeming fascination here is that the entire visual fanfare of this artwork – when you come upon it in the Uffizi Gallery in Florence, it almost causes you to step back in wonder at its opulence – seems to conceal a story behind the well-known story of its subject matter. It was made for a Florentine church, Santa Trinita, and its subject is one of Christianity's central acts of gift-giving by a group of astrologers, magi, kings – they have been called all these things at different times in the evolution of their identities.

So that act of gift-giving is the central subject of the painting. But what we also feel is that the gift is not so much contained within the narrative itself, as in the gesture of the banker. It is his gift, the sheer, overweening pomp and costliness of it all, that strikes us as extraordinary. In fact, the entire elaborate construct feels like so much more than a painting – well, to begin with it is several paintings in one if we also take into account the stories in the roundels above the central panel (God the Father, Abraham, the Prophet Micah) and in the predella beneath (various scenes from the story of Jesus, beginning, on the left, with his Nativity). So in the sheer comprehensive sweep of its subject matter, it is more a sermon than anything else.

But there is more than that. When we marvel at the gilded intricacy of the quasi-architectural features that have been incorporated into its

presentation, we feel that it is more like a shrine that is on the way
to becoming a fantasmal building. We feel that it ought to be hovering
in the air in front of us, borne up by a brace of angelic studio assistants.
Was Strozzi making this gift in order to appease the God that he
purported to worship? Perhaps. Then, as now, banking was a morally
dubious activity. The church frowned upon it. If you could blame usury
on the Jews, those deicides who chose to spare Barabbas, that could
be construed as an excuse of a kind. But were not bankers in general,
Christian and Jewish, engaged in the business of lending money at
interest, of conjuring wealth for themselves from the air? So we can
speculate that this painting is an act of giving back to God just a bit
of what this banker has snatched away.

Frankly, does it not almost stink of luxury? Luxury going hand in
hand (and rather uneasily, we feel) with due reverence for the narrative
moment, of course, which, we dimly recall from the biblical account
in the Gospel according to Saint Matthew (the only place in the
New Testament where this particular scene is described), had at some
point to do with the hardships of rejection by the keeper of an inn.
(That harder scene, endured perhaps in more inclement weather, is
relegated to the bottom left-hand corner.) Is there hardship here in
the centre of this glorious polyptych? No. In spite of the fact that we
see a gorgeously strokable cow, there is little that is whiffily stable-like
here. The canopied structure behind the Virgin looks robust enough.
The women who are intent upon their private conversation behind
the bending back of the Virgin are usually described by scholars as
midwives, but they are midwives with a heightened sense of fashionable
courtly dress, especially the one with her back to us, whose tumbling
robe – and what a lovely, wayward line it makes as it falls – seems to
be worked and hemmed with gold.

And it is not the painting alone which almost smothers us in the gildings of luxury. There is such swagger here, and such an overwhelming narrative abundance, an abundance which takes in much more than the gift-giving might lead us to contemplate. As we roam around, looking at detail after detail, we see two kinds of world. One is sacred and reverential, and it is embodied in the attitude of the magi themselves, and especially that of the oldest, who, having removed his crown, kneels in order to let the infant have a feel of his bald pate. But stray beyond the edges of all this haloed/ hallowed gift-giving, and we are plunged into a world of unruliness: wild animals, and even unacceptable behaviour of various kinds (including rank criminality). Still, the treatment does not err quite so far in the direction of breezy irreverence as the painting of this same biblical moment by Bruegel the Elder that can be seen in London's National Gallery. God forbid that a banker should descend into disreputability.

# The
# Crushed
# Blushings of
# Autumnal
# Excess

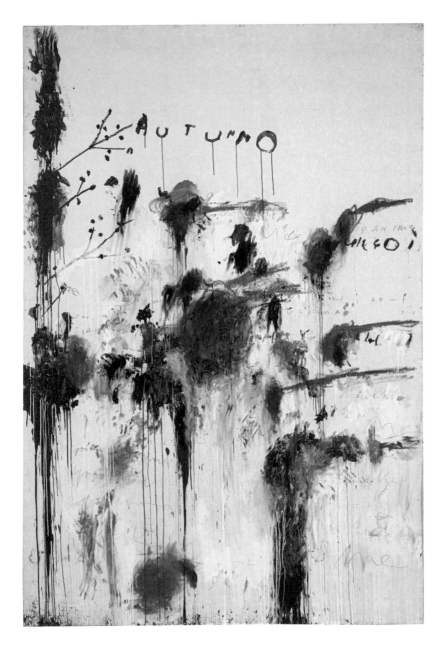

*Quattro Stagioni: Autunno* (1993–95), Cy Twombly,
323 × 225.4 cm (127 ¹/₈ × 88 ³/₄ in.), Tate Modern, London

When I last saw this huge painting – it is more than the height of two tall men – it was lying on its side in the Tate storeroom in London, and its presence there, struck down like that, penned inside the nowhere space of a mere warehouse, reminded me of a great beast wounded in a skirmish. Wounded, but still not quenched.

Why so? Because Twombly's entire cycle of four paintings about the seasons – he painted the whole cycle twice over in Italy between 1993 and 1995, and the first of these is in New York's Museum of Modern Art – seems to be a living and breathing evocation of the different moods of the passing year. And this one is moody with the full, ripe energy of autumn, that season which, in the words of the poet John Keats, quoting from his ode 'To Autumn', is a season of mist and mellow fruitfulness. Fruitful certainly, but is there much mellowness here too? Not exactly.

Mellow partially suggests a kind of idling passivity, and this painting is punchily celebratory, lyrically furious, a kind of fist-squeezed essence of autumnal superabundance. Wildly energetic, it is a painting constructed from a sequence of violent painterly gesturings, uprushings, downstreamings, which move up and out, from a warm cream ground – scribbles, explosions, eruptions, blotchings, blushings. We can feel and see the hand of its maker, tamping here, finger-working there. Its bursts of mauve are rich, crushed-grapey explosions. The drips stream down, top to bottom; other marks rush sideways.

At its centre, there is a dark node of merged colours – violet, yellow, green – squeezed together as if ground in a pestle. As so often, there are ghostly glimpses of text wafting across the surface, some of which fade into unreadability – we read the word 'Pan' twice over, one after

the other, like a drum beat, as if that lusty piping, goat-footed god of all things wildly natural is here to preside over this entire painterly enterprise. It is as if everything has emerged into abundant life all at once – the painterly equivalent of a shriek. The painting's name is hand-written in Latin, in crude capital letters, childishly hasty, as if to pinion it to the great Roman poets who celebrated natural abundance – such as Virgil, whose *Bucolics*, a much earlier celebration of the cycles of the seasons, is part of Twombly's repertoire of key texts.

Much has been said of Twombly's reverence for Nicolas Poussin, greatest of all the great painters of natural abundance – no one has ever equalled the ability of Poussin to render a majestic tree in full leaf, and there is Poussin here certainly, but there is much that is wholly other too. This fierce, gestural mark-making reminds us that Twombly was as much a second-generation heir to Abstract Expressionism as an inheritor of the classical tradition.

And so what we have here is a painting which seems marvellously suspended in its painterly impulses between Europe and America, thoroughly, hot-headedly American in the freedom, the sheer bravura, of its making, and wholly, classically European in its reverence for and fidelity to the idea of the unchanging, miraculously self-renewing glory of the seasons.

# When
# the Exotics
# Steamed in
# to Gawp at
# the Seaside

*The Beach at Trouville* (1875), Eugène Boudin,
12.5 × 24.5 cm (4 ⁷/₈ × 9 ⁵/₈ in.), Courtauld Institute, London

The beaches of Normandy have suffered various terrible incursions from time to time. The one that we are a witness to in this painting, which dates from the second half of the nineteenth century, is of a relatively benign kind.

It is always of vital importance how far away we position ourselves when scrutinising a two-dimensional object on a wall. Think of some of the huge portraits by the American painter Chuck Close, for example. In order to enjoy his portraits, we need to be a goodly distance away from them. The closer we approach, the more they are inclined to dissolve or disperse into an unreadable frenzy of very calculated, and seemingly almost formulaic, mark-making. As we walk towards them, they begin to disappoint us.

This painting, so modest in size – it is a narrow thing whose shape seems to fit perfectly its subject matter – hung in the top-floor gallery which overlooks the gorgeous, scalloped staircase at the Courtauld Institute in London, amongst other French paintings, many of them landscapes too, of a roughly similar size. In this case, we need to be at least two feet away – not much more than that – in order to appreciate that it is partially dependent for its success upon the fact that it is edging towards abstraction. That is exactly the effect that Boudin wants to achieve. He doesn't want us to home in on details that would explicate its meaning too readily, that would tell us exactly what is what and where and why. What is to be seen here, in all its slightly tantalising vagueness, needs to be just a touch exotically beyond our reach.

What also needs to be pointed out immediately – and this fact is not immediately evident – is that it is a very amusing painting. The fact is that Boudin, who regularly painted the Normandy coast during these

decades (as did his more famous friend, Claude Monet), is drawing
our attention here to a strange species of – avian perhaps? – invader,
a type which would have been wholly unfamiliar to earlier generations.
This species of invader began to visit these shores, generally during
the summer months, at the end of the third decade of the nineteenth
century. The marvels of technological advance had made it possible.
These invaders, who generally travelled in some style along with their
enormous retinue of poorly paid pamperers, came from the heart of
Paris by steam locomotive. They were the haute bourgeoisie, who,
thanks to the railways, were coming here to enjoy the delights of the
seaside experience for the very first time.

As Boudin makes clear to us, they were utterly different in almost
every way from the usual inhabitants of these parts. The fishermen
and their fisherwives would have gaped at them in wonder, asking
themselves why such people were here, and what form of livelihood
they could expect to gain by merely standing and chortling and staring.
What are they doing here in such clothes? Yes, they are all settled,
huddled as if for mutual protection, on this beach, like a huge flock
of exotic wildfowl, brilliantly bedecked in plumage and other forms
of finery. We notice that they are tonally similar to each other. This is
clearly a form of camouflage to deter or to confuse the ranging, circling
predators, of which – who knows? – there may be many. There is only
one tiny splash of colour amidst the greys, the muted blues, the blacks,
the creams, the beiges in this painting, and we fear that it may be too
dangerously demonstrative for its own good. What is more, the element
of camouflage extends to the sea and the shoreline and the very sky
above their heads.

Everything, gently and mistily, melds and merges into everything
else. We cannot see very clearly where the shoreline ends. We do
not know exactly where the sea begins. We cannot register where the
horizon line finishes and where the sky starts to make its mark.
Everything flows into everything else like a sweetly musical fantasia.
The entire tiny universe of this painting is of a piece. These exotics are
not here to enjoy the delights of bathing. They are here to look at the
sea, and to be seen doing so in each other's company. And yet that is
not exactly the case either. Some appear to be looking seaward while
others do not. Yet others are addressing each other. This is merely a
pretty, and perhaps a blustery, context for an extended *causerie* of the
kind that could just as easily have taken place in a drawing room. So
they have brought their own identities here, these exotics. They are
who they are no matter where they happen to be. And here they are
beside the sea for their entertainment. But the sea is a mere adjunct
to their activities, a pleasurable context, we feel. They are not about
to engage with the sea or to profit much by its commanding presence
here. Although these boundless waters are in evidence, they are fairly
tangential really. Meddling with them at all would be inconceivable.
There is no hint that such a thing is about to happen. There is too
much self-absorption about this grouping for such speculations. To
step in to these dangerous waters would be one step too far. A boat
would be out of the question. It would be far beyond the strictly
circumscribed bounds of their definition of leisure. It would also
cause ruination of their fine footwear, and risk staining irretrievably
the lower reaches of their abundant costuming. But are they not hot?
 Don't address me with a question of such impertinence.

# A
# Savage
# Crew in
# Brilliant
# Light

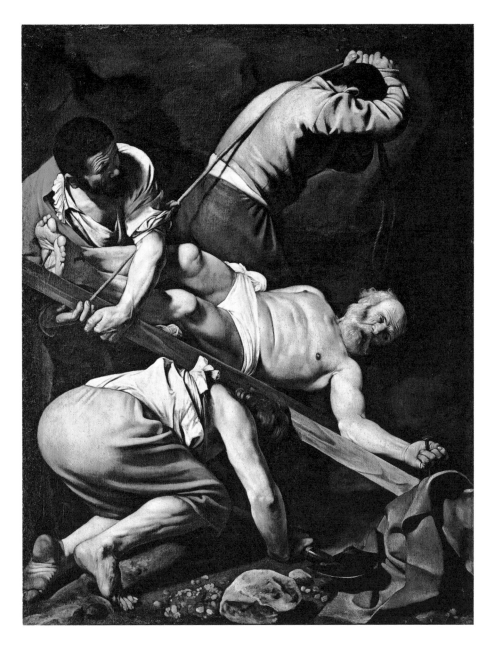

*Crucifixion of St Peter* (1601), Caravaggio,
230 × 175 cm (90 ¹/₂ × 68 ⁷/₈ in.), Santa Maria del Popolo, Rome

Caravaggio had been painting large altarpieces for only two years when he was commissioned to make this one for a church in Rome. The acquaintance of a cardinal had made it possible. Ah, large-scale ecclesiastical patronage. The stuff of any young painter's dreams. But what a shock it is! No wonder that the parishioners hated it so much when it was finally unveiled – and they really did hate it.

Its sense of rude urgency is quite extraordinary. You can tell at a glance that it was not worked up from a series of painstaking preparatory drawings. That was the more customary way. That was what Rubens, for example, would have done. No, this is a quite arresting depiction of life dragged in from the street. This is a quartet of ordinary men, day labourers, street loungers, bar proppers, pressed into service in exchange for a sweaty palmful of scudi, hustled into a studio brightly lit with torches, by some painter with a slightly manic, homoerotic gleam in his eye.

Yes, what we have here is surely not a painting at all but something more akin to the urgency and instantaneity of a photograph. Is that not right? In spite of the fact that this work was done in 1601, and that it still hangs in the church of Santa Maria del Popolo in Rome, it surely should be attributed to an epoch in which photography, and all it could capture of the moment, was beginning to seize the initiative from painting. What we have here is a graphic, snatched instant of the crucifixion of an old man. There is no dignity here, no serenity, no pity. And certainly not much religion to speak of – in spite of the fact that its subject is the crucifixion of St Peter, the man who insisted upon being crucified head down, which means the other way up from his Lord and Master.

This is surely a snapshot of some no-one-in-particular being caught by the undignified speed and the incontrovertible truth of the painter's cameraphiliac's eye. What is its real subject then? Human sweat and toil. There is bustle and labour and heaving and pulling and groaning. The slightly dazed, bewildered, bearded old saint in the loincloth looks around and up, a little taken aback at the sight of the heavy, brutish nail that has been driven through his clenched left palm. What in the name of God is it doing there? What kind of terrible dream is this that he hopes to awake from in paradise? Meanwhile, the rest of the savage crew of labouring men simply do not care, do they? It is simply not what they are concerned about. There is a job in hand here, to hoist an old man up on a couple of crossed planks as quickly as possible – yes, who knows what the hourly rate might have been for this sort of hard, difficult body toil in those days, and how many others there were standing or lying nearby, being threatened and taunted by Roman soldiery as they waited for similar treatment?

What is so marvellous about the seizing of this moment of pell-mell activity is how utterly convincing it is. It is as if we have been struck on the jaw. Everyone is on the go. All the characters here are pulling or twisting or turning or weight-bearing. Everyone is moving in a slightly different direction. That helps to energise the entire work. Peter, who is pretty solidly muscular for an antique saint, is writhing sideways to get a better look at his humiliation. The man with the rope is heaving it up his back, straining to get the cross upright. It is as if the work is enacting the crude business of pulling itself apart. It is all so sudden and awkward within the fairly tight compositional space of this painting.

We immediately recognise how shocking this version is though, and why it would have offended so many. This is a painting, commissioned by the church, about the crucifixion of the man who had been anointed

by Jesus himself to be that church's rock, which is utterly drained of
the kind of spiritual resonance we might expect from any treatment
of this subject matter. Caravaggio is determined to snap men as
mechanisms, men as heaving and sweating job-doers. Look at the filthy
soles of the feet of the man whose buttocks are presenting themselves
to us so fully and so roundedly. The local parishioners took particular
exception to those feet. Have prideful buttocks ever played such
a dominant role before in a religious painting? That young man is
nothing but an abject fulcrum for those two planks; he is the means
by which it will be hoisted up into the air. Has he been working already?
Perhaps. His right hand is still closed over the end of his spade. Perhaps
he has been digging the hole for the bottom of the shaft of the cross to
be plunged into. It is all so sweaty, so punishingly abject.

But it is also something quite other than all these things. This is a
glamorous painting of these men. The dramatic lighting helps to lend
it that glamour. The washings of light across skin and cloth have helped
to give these bodies a real, toned shapeliness, a theatrical panache of
sorts. We admire their beauty. Caravaggio too no doubt.

# The
# Teasing
# Allure of the
# Malevolent
# Protectress

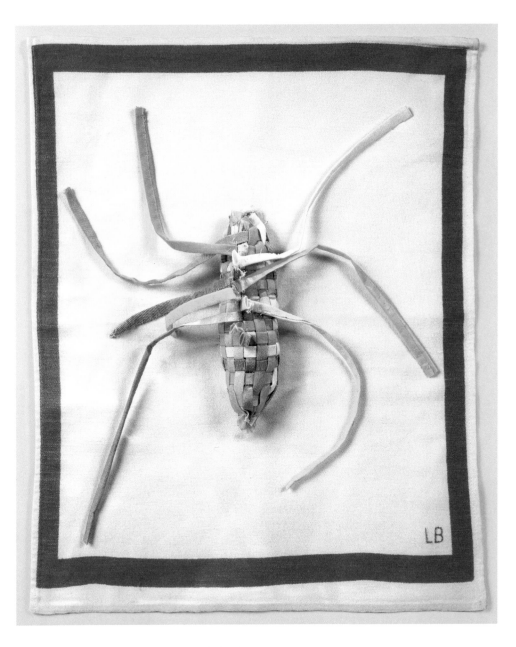

*Spider* (2007), Louise Bourgeois,
41.5 × 33.6 × 6.3 cm (16 ³/₈ × 13 ¹/₄ × 2 ¹/₂ in.), private collection

The closing lines of Robert Lowell's great poem 'Mr Edwards and the Spider', even as they probe and tilt at the primitive, hell-fire puritanism of a bygone New England, also seem to summarise a common attitude towards the spider itself: '... but the blaze / Is infinite, eternal: this is death, / To die and know it. This is the Black Widow, death.'

Yes, to many a nervy, fearful soul, the spider is the stuff of nightmare. It lives to entrap the unwary. Christianity commonly saw in the spider a symbol of the devil, who lives in order to deceive. Minerva turned Arachne, that much accomplished seamstress, into a spider as a punishment because she was better at the art of weaving than Minerva herself, who was the protectress of that trade, a kind of guild mistress of the mythological world. All the odder then that Louise Bourgeois, who spent sixty years of her extraordinarily long life making spider images – the first was in 1947, and it looks boisterously, almost harmlessly cartoonish – generally spoke of the spider other than in terms of entrapment.

To Bourgeois, the spider was often the symbol of the motherly protectress. What is more, the web the spider wove could just as easily be regarded as an object of great beauty and elegance – many of Bourgeois' fabric works, though seemingly edging towards abstraction, can also be read as playful variants upon the delicate, wave-like out-fanning of the spider's web.

What the artist may be presenting here is a spider as a force for good – quite the opposite of the traditional Christian view we referred to above. What is more, the spider – as Robert the Bruce discovered – is a resourceful creature, a creature which has the capacity to show us the way. When a web is destroyed by a careless or a malevolent hand,

the spider does not attack its foe. It works patiently away at repairing the damage. There are further reasons why Bourgeois' spider might be regarded as a relatively benign creature. Autobiography undoubtedly played its part. Her mother was a restorer of Aubusson tapestries, and Louise herself assisted in that workshop as a child, repairing a missing foot here, a leg there. So weaving, for the Bourgeois family in general, and for this child in particular, was a healing, restorative activity. Far from destroying or entrapping, it returned the damaged object to a condition of beauty.

This particular spider, a small, delicately plumped fabric work with a gorgeous trailing of polychromatic legs, could not be more visually alluring. Each of its sprawly legs is of a different colour, as if tricked out for some cabaret performance. Those feelers slither their way out towards that entrapping boundary wall of thickish sky-blueness, which is a lovely tonal match with all the rest. It is also quite small, like a snug-shaped, nosy-ended cartridge. All this is fairly unusual.

Many of Bourgeois' spiders were not small at all. In fact, they were huge, and in spite of much of what has been said about Bourgeois' positive attitudes towards this creature, they look menacing, terrifying. Their staging in exhibitions often plays into their Hitchcockian qualities – they hang on a wall, half in shadow. They loom over us. They may be emblems of the arachnid as our supreme protectress but, more to the point, they are also there to repel by the sheer horror of their looming, predatory-looking presence. Not so this one, though. This is no Black Widow called Death. This is reassuringly lovely. Unless, of course, all this alluring colour, all this under-and-over stitch-work, is a lulling, sneakily come-hither tease of make-believe.

# God's
# Sobering
# Judgement

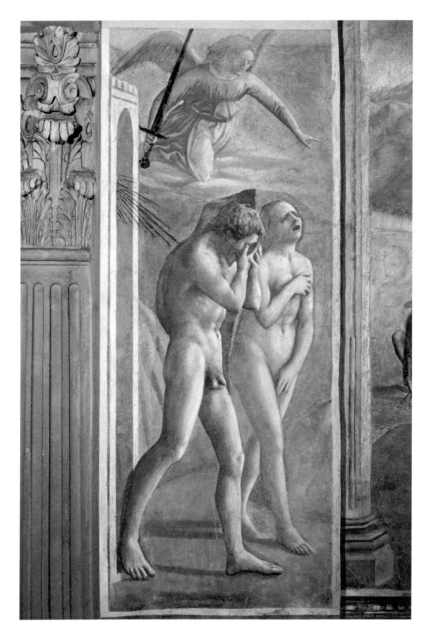

*The Expulsion from the Garden of Eden* (1425–27), Masaccio,
208 × 88 cm (81 ⁷/₈ × 34 ⁵/₈ in.), Brancacci Chapel,
Church of Santa Maria del Carmine, Florence

The expulsion from the garden is an event as harsh as it is swift and pitiless. Everything is happening all of a rush, as the hovering angel, sword at the ready, afloat on a cloud of her own finery, oversees the departure from the Garden of Eden, that place of natural abundance and sometime innocence. The point of departure is through a tall, narrow, colonnaded, castellated gate, as any citizen might be expelled from any city – as Dante, for example, was expelled from Florence in 1302, never to return. But his was a civic expulsion. These two are guilty of much graver crimes.

These two, Adam and Eve, were the first and only citizens, and they are being cast out, naked, and almost exaggeratedly aware of their own nakedness (see how Adam veils his eyes, and Eve conceals her breast and pubic hair), because they have broken a sacred compact with their God. The landscape outside the gates is arid and mountainous – the mountains seem to rise up, in all their bleakness, their tawny, arid thirstiness, all of a sudden, like boils on skin, as if confirming the sobering wisdom and terrible irreversibility of God's accursed judgement, and the two exiles are engaged in nothing other than self-absorbed lamentation – Eve's mouth hangs open in a gasp of seeming disbelief. Her eyebrows are fierce downward diagonal strokes. Adam, in the way he presses his fingers into his eyeballs, masochistically, seems to want to deprive himself of the ability to see that which they have brought upon themselves.

It is a remarkably narrow fresco, pent in its atmosphere, and it is one of a cycle, ranged in two tiers, one above the other, on the walls of the chapel of a church in Florence, as one might present Bible illustrations in some great book. The entire cycle was executed by three

painters. There was Masolino, his young assistant Masaccio, and, some time later, Filippino Lippi. The young Michelangelo came here and did a drawing based on Masaccio's masterpiece – you can see it in the Louvre. The styles of Masolino and Masaccio are very different from each other. When Masolino shows us the two being tempted in the garden, his figures are more stiffly statuesque. They seem to be facing in the direction of classical antiquity. In spite of their tragedy, Masaccio's Adam and Eve are much more wholesomely human. Adam's flanks, penis, ribcage, biceps are not those of a wretched outcast. They are those of a man whose physical virtues may yet transcend the curse with which God has blasted him. There is a manifest pride in the depiction of the human form here, a bold, striding – and does not the very first man seem to stride, boldly? – optimism. That boldness of stride is made all the more emphatic by the powerful shadows that help to define the shape and the movements of his young and shapely legs.

Such is the rich paradox at the heart of this great painting. 'Tomorrow to fresh fields and pastures new,' wrote John Milton at the end of 'Lycidas', his great elegy to Edward King, the college friend who died at sea. Could this be Adam's cocksure thinking too? Perhaps the gift of knowledge would, wisely used, prove to be more virtue than curse.

# A
# Message-Bearing
# Simulacrum
# of Treeness

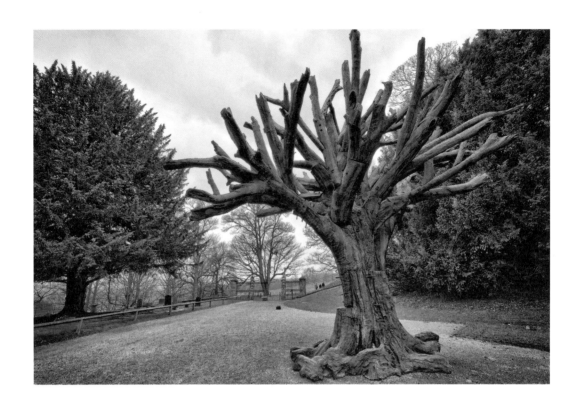

*Iron Tree* (2013), Ai Weiwei,
628 × 710 × 710 cm (247 ¹/₄ × 279 ¹/₂ × 279 ¹/₂ in.), Yorkshire Sculpture Park

Elsewhere in this book you will find John Constable's small painting of the trunk of a great elm tree – so bulky and so vividly corpulent that it is almost huggable – shouldering its way into the space around such words as these. Here is another tree, this time captured on a sullen Yorkshire afternoon in springtime, on a day when the lapwings had just returned to their old nesting grounds in a nearby field. This tree is Chinese in origin, and it sits amongst English yews, in front of an eighteenth-century chapel, in a sculpture park.

Unlike Constable's, this tree is neither more nor less than a symbol. In common with so many of the works of Ai Weiwei, it proceeds by stealth. It does not sloganeer. It does not bang drums. His art is often not so much an art of protest as an art of life affirmation by sleight of hand.

In part, it has the look of a tree. And in other respects it does not, not quite. It is, for example, a vivid orange tree – and by that I do not mean that it will in time be glad-handing the fortunate few with a crop of oranges. No, I mean that it is a rusting tree, in hue and actuality, and that it will continue to rust and to rust – it had the silvery sheen of new metal in 2013, when it was first put on public display inside that nearby chapel – until it becomes too dangerous for its own good. At which point it will suffer some equivalent of felling.

Yes, here we have a tree amongst old trees which is in fact a simulacrum of a tree. It consists of ninety-seven separate parts, and each segment is cast in iron from a Chinese tree part. Its inspiration comes from street vendors of wood in Jingdhezen, northern China. The whole is awkward, ungainly, fistily comical and wonderfully tenacious. In order to be itself at all, each limb or part-bole has had

to be bolted and screwed together to every other part, as if it were a work of human manufacture. Which it is. The elements do not quite fit – one section of its massive trunk seems to be sliding sideways, drunkenly. The limbs gesture skyward, wildly, helplessly. Rivulets of rusting iron look as if they might just taste tangy. Its characterfulness also comprehends something rather nasty and even fairy-tale-cronish too.

We try to decide whether these are cast parts from one tree or many. We fail to reach a final conclusion. It is undoubtedly a tree of sorts, but this tree is also a message, we cannot but feel, about the condition of man in the world, this awkward, bolted-together creature who is forever striving to cohere as something credible and singular, forever striving to hold his own amongst more authentic versions of himself. Ai Weiwei is by no means the first person of great imaginative reach to extrapolate from tree parts to the nature of the human condition. Read Jonathan Swift's great *Meditations upon a Broomstick*, for example.

At least this tree is the right way up.

# The Abiding Stench of the Charnel House

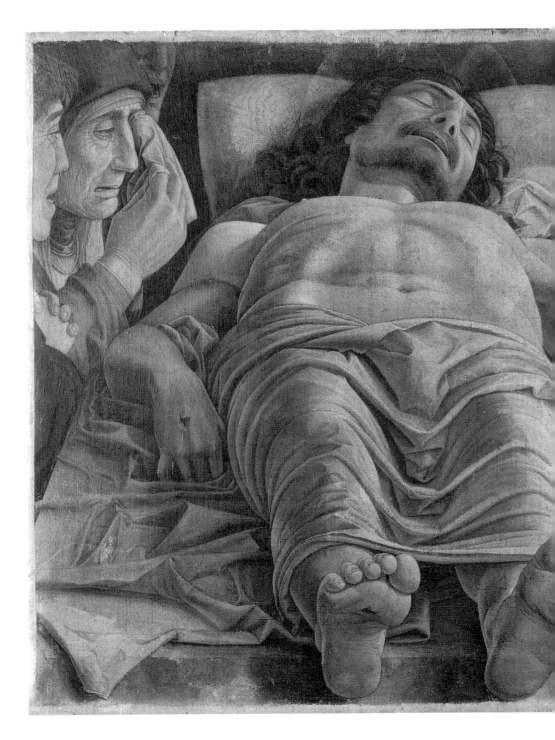

*The Dead Christ* (c. 1480), Andrea Mantegna,
66 × 81 cm (26 × 31 ⁷/₈ in.), Pinacoteca di Brera, Milan

We are wholly accustomed to contemplating the person of Jesus in his death-wracked agony on the cross. We see how the body is both stretched in its suspension, pulled earthward by its own weight like so much skewered meat, and often skewed to the side, painfully and unnaturally. And yet, generally speaking, there is usually a degree of compassion in the painter's gaze, and an unspoken agreement between patron and artist that the whole must tend towards the heroic and the noble. After all, the entire world must be persuaded to agree that this man is more than a mere man amongst mere men.

By comparison, this daringly experimental view by Mantegna takes us aback. It seems to incline towards ugliness or, at the very least, a cool impartiality that seems to border upon irreverence. Its presence here feels so sudden, so jarring, so quickly upon us when we catch sight of it. It looks like a corpse on a mortuary trolley that has been slammed into our knees, a partially exposed specimen of its kind, presented to us here, feet-first. Except that this is a marble slab on which the body lies. It puts us in mind somewhat of a great drawing by Mantegna that may have been a preparatory sketch for this painting. That one was called *Man Lying on a Stone Slab*. There the figure, lying supine, was, though semi-comatose, undeniably alive, and even rising up on its elbows.

Not so here.

Here there is nothing but the oppressive stench of some charnel house ripped straight out of the pages of a novel by Emile Zola. The space here feels strangely small, pent, confined, fuggy with death, ghastly, ghoulish, tomb-like. The presences of Mary, John (that most favoured disciple) and Mary Magdalene (the identification of this third human presence, the one furthest away from us, is little better than

guesswork because we get little more than a semi-occluded view of the lower face) are almost too close to the cadaver for comfort, squeezed up against the body, mouths agape, as if in horrified and near incredulous fascination. The limited range of colours Mantegna is using here – these pinks, greys, dusty blues – both add weight to the general atmosphere of dolour, and seem to draw the space in. The face of Mary – see how she and John spill tears, she much more extravagantly as she tamps at her eye – looks mask-like and almost haggard with grief. The angle of view is so low – was Mantegna intending that we should look at this painting from below? – that the body seems curiously, almost grotesquely, foreshortened. It looks a little like the body of a dead dwarf, with a large and over-heavy head. The ribcage, faintly marked with almost decorative lacerations, looks oddly swelled as if pumped until it is on the brink of manly posturing. The wounds on hands and feet are curious too, open and dry. The flesh looks cracked and dusty. We are not accustomed to having the soles of Christ's feet thrust out towards us in this way – as if feet were more important in the emotional scale of things than the face or the hands. The body is that of a relatively heavy man of some musculature. That is unusual too. Representations of Christ most often swing between the handsomely, homoerotically able-bodied and the ascetic. Much more unusual is a plumpish Saviour. Or is this dramatic use of foreshortening playing tricks with us? The body, with its horribly pallid, lolling head, looks thoroughly, quite humdrumly, dead – a dead weight you could say – as if this were any man's death, anywhere. It feels entirely robbed of its aura of sanctity, saintliness, special otherness. It does not seem to be on the brink of promising that it will rise again to speak of the coming kingdom to

its amazed and adoring proselytes, or, in due course, to set about harrying hell or undertaking other serious, posthumous duties. In fact, in mood, it puts us in mind of Ron Mueck's *Dead Dad*. It's thoroughly gone, never to return. The rucking of the fabric is quite magnificent too, flowing down onto that slab in keenly etched rivulets. *Ecce homo* indeedy.

# War's
# Terrible
# Desolations

*Cosmos and Disaster* (c. 1936), David Alfaro Siqueiros,
60.8 × 76.1 cm (23 ⁷/₈ × 30 in.), Tate Modern, London

Civil war is a treacherous, insidious, self-mutilating business, dividing region from region, neighbourhood from neighbourhood, settings members of the same family at each other's throats. Its wounds suppurate down the generations. An external aggressor is so much easier to demonise, and therefore to set aside.

And nowhere is this more the case than in Spain, whose brutally divisive civil war, waged between 1936 and 1939, continues to cause anger, suspicion and obfuscation, and to block the ability to remember the past with clarity and honesty. Many artists responded to its horrors from the painful distance of exile – think of Pablo Picasso's *Guernica*, created in Paris, and the many out-takes that he made from it such as the celebrated *Weeping Woman* of 1937 based on his lover Dora Maar. Many came from far away to fight in the Republican cause – the English poet W.H. Auden served, somewhat unwillingly, as a broadcaster of propaganda. David Siqueiros, the great Mexican muralist, arrived there in 1937, but before his arrival he had created a work called *Cosmos and Disaster* in a more generalised response to the outbreak of the war in June 1936. If this is a work of political witnessing, it is also very uncharacteristic of Siqueiros as a political artist.

Siqueiros is at his most familiar as a strident, message-bearing muralist who tends to wear his heart – and his political allegiances – on his sleeve. Those works possess an easily readable narrative content. We can recognise the heroes at a glance. Not so here. This phantasmagoric work is reminiscent, in its evocation of the terrible, hellish nowhere land of the battlefield, pitted, blasted, rutted, brutalised almost beyond recognition, of some of the paintings and drawings of trench warfare during the First World War made by the likes of Nash,

Nevinson and Dix. Yet it goes further than that. It moves further in the direction of abstraction, and in doing so it seems to be imaginatively enacting the artist's own agonised response to his presence there. There is conflict going on across the surface of this piece – the paint is blistered, and scraped back, intermixed with grit, sand and fragments of wood. The surface of the painting is drippy and hazy, rubbly, uneven, heaving, swollen, slightly rippling. We cannot calculate our distance from it. What are these tiny riddlings of red, so small and so impish? The aftermath of fire? What exactly looms here though? The darkness of smoke, night, hell, all rolled up into one. The entire scene appears to be afloat on its own dingy ground. Are some of these tiny barrings of snapped-off wood reminiscent of part-destroyed bridges flung across ravines? Undoubtedly. Do these hollowings remind us somewhat of shell holes? Undoubtedly.

But never quite enough because this scene, in all its harried and haunting desolation, seems suspended above particular places, and its title appears to be inviting us to consider an even greater destruction than this – the death of the cosmos itself, for example. So we could call this scene an enactment of a kind of psycho-drama, which begins with the wounds, inner and outer, suffered by the human, the pain of all that terrible witnessing to death and destruction, and ends in the death of everything. Because, and unlike many of those scenes from the trenches, there is no one here left to see. This scene is entirely people-less. The only one left is the maker of the painting itself. Everything – and everyone else – has been blasted to hell and back.

# The
# Indomitable
# Solidity
# of the
# Thing Itself

*Study of the Trunk of an Elm Tree* (c. 1824), John Constable,
30.6 × 24.8 cm (12 × 9 ³/₄ in.), Victoria and Albert Museum, London

The scholastic philosopher Duns Scotus coined the word in the Middle Ages: haecceity. It means the 'thisness' of a thing. Has John Constable captured the 'thisness' of a tree as perceived by a human being – of a tree in general or of an elm tree in particular, we might ask ourselves? – in this oil sketch?

It was Lucian Freud who first singled this painting out for careful attention back in 2003, when he made a choice from the works of Constable for display at the Grand Palais in Paris. How he displayed this little painting then came as something of a shock. It was entirely separated out from all the rest, on a wall of its own, at the exhibition's entrance, and it was neither framed nor adorned in any other way whatsoever. It merely hung there, ragged, creased edges, drawing pin marks and all, as if in acknowledgement of its own modesty. In fact, exactly as it is displayed now.

Why is it so interesting? In part, because it defines itself against so much of Constable's later works, all those great, critic-pleasing, fame-thirsting six-footers, for example, with which he hoped to ensure his lasting place amongst the great painters of these isles. This tree was not amongst those exalted canvases. In fact, it would probably have tickled him to have it singled out in this way. It was given by Isabel Constable to the Victoria and Albert Museum in London after his death, one of his many effects. It had never been shown during his lifetime because he would have regarded it as a constituent part of a painting, one of those many details which he knew that he had to get right, and not in fact the very thing in itself that we began by identifying it as being. It would have stood ranged with those many great and impromptu studies of clouds and dock leaves, brilliant notational efforts at which,

being a meticulous man, he so excelled. As he once put it, with endearing nonchalance: 'I know dock-leaves pretty well, but I should not attempt to introduce them into a picture without having them before me.'

And that is exactly what happens here. We have this elm before us, in all its enduring magnificence – everything else falls away before its mightily steadfast, burly, Falstaffian presence, as if it is here both to command over and to define the very spirit of the place that it occupies. A tiny bird pays witness off to the right, in a sunlit glade, and the size of that bird helps to aggrandise the presence of the tree. Is it anthropomorphised in some way? Of course. Don't those upper limbs seem enfolding, if not embracing? It is painted with such fastidiousness – see how each separate panel of bark seems individually lit, and each one of them in one or another of such a multiplicity of glancing colours – there are pinks here, blues, browns and much else... Tussocky grass grows around its base. And there it stands, engulfing the eye of the beholder, in all its mighty singularity, all its indomitable, unbudgeable *haecceity*.

# The Coy,
# Voluptuous
# Prize

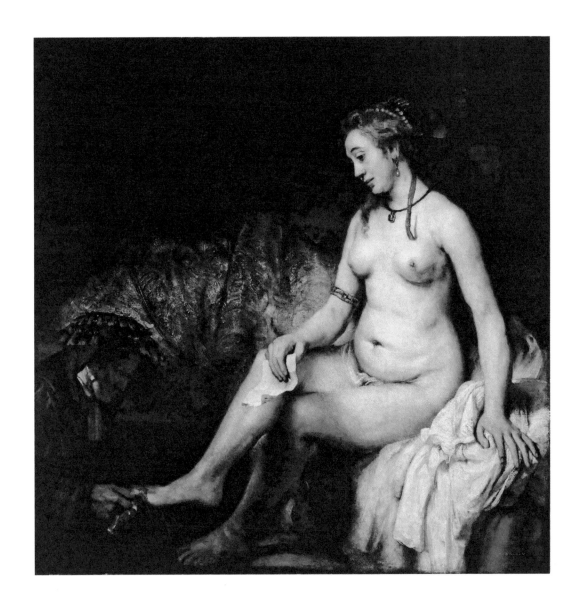

*Bathsheba with King David's Letter* (1654), Rembrandt,
142 × 142 cm (55 ⅞ × 55 ⅞ in.), Musée du Louvre, Paris

In the later years of his brilliant career, Rembrandt was much given to depicting varying degrees of self-absorption. His late self-portraits offer us brilliant examples of how, in the repeated putting on and throwing off of a variety of costumes, he was in fact examining the different ways in which he contemplated and reflected upon his own image of himself as he began to decline into physical decrepitude. Something similar is happening in the work on the opposite page, the greatest of his nudes. Its hugeness as a painting seems to call for drama – and in the past Rembrandt would almost certainly have answered that call. In fact, its drama is entirely within. It is a study of inner feeling and emotional conflict, and much of its emotional force is contained within the facial expression of Bathsheba herself.

The painting also assumes some detailed knowledge of the story that it is re-telling. Bathsheba was the wife of Uriah the Hittite, a commander in the armies of King David. King David spied upon and then seduced her, and painters customarily showed her with the king in attendance, lusting after her from a balcony. In fact, many Dutch painters regarded her as an object of lust and little more. Here Bathsheba is painted much more sympathetically. She is as much a victim as the object of our admiration. Against her knee rests the letter written by the king, inviting her to attend upon him. Face down, only a corner of the text is visible to us. The consequences of that seduction were manifold. Uriah died in battle, and the son of the adulterous passion died too.

An elderly handmaiden, almost in shadow, washes Bathsheba's feet, an act of cleansing of great significance because it will be followed by that act of sexual sullying and marital betrayal, which would have far-reaching consequences for the entire Kingdom of Judah. The Bible

tells us as much. David slept with Bathsheba after 'she was purified from her uncleanness'. The handmaiden is attending only to the matter in hand, as if totally unaware of the significance of an act so familiar to her and so emotionally uncomplicated. Bathsheba, on the other hand, though seemingly distracted, is anguishing over worlds of future sorrow. Her naked body sits almost against the picture plane, offered up to us in all its voluptuousness. Behind her is heaped her magnificent garment, whose fine, riddling threads glow against the dark. Her body is turned towards us in full self-display, but her face is in profile. We are not invited to dally with her brazen gaze.

This is a history painting, but it is also a depiction of a nude, and we sense that there is some degree of conflict between the two kinds of painting, that one gently tugs against the other for supremacy. Here is a complicating fact that may help to explain the intriguing tension of this work. Rembrandt's model for Bathsheba was in fact his mistress, and his adulterous liaison with her sat uneasily with the Protestant rigour of the moment. Rembrandt has more in common with King David than might at first be surmised.

# The Hurrying Ahead of the Ever Disappearing Jesus

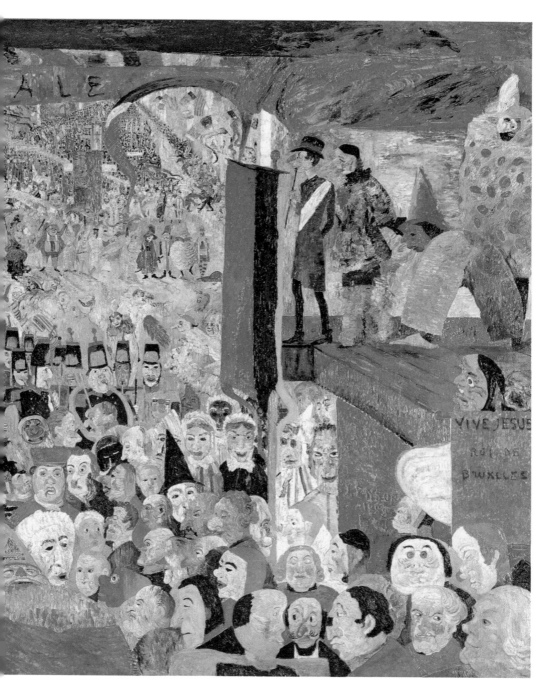

*Christ's Entry into Brussels in 1889* (1888), James Ensor,
252.7 × 430.5 cm (99 ½ × 169 ½ in.), J. Paul Getty Museum, Los Angeles

There is a kind of unbridled, no-holds-barred madness about so many of the paintings of James Ensor. But aren't we quite pleased to be let loose inside the funhouse of this nineteenth-century Belgian painter's teeming mind, jigging about, giggling helplessly, trousers at our ankles? It is rather as if we have found ourselves in a swimming pool, out of control, moving around in all directions at once.

We are not quite in charge of the situation. We entered into this pact of looking as connoisseurs of sorts – or so we thought. We arrived at this place, of our own free will, in front of this tricksy, two-dimensional object to do the looking, to navigate our way – through and across, up and down – exactly as we saw fit. But no sooner did we arrive than our eyes were snatched away from us, and someone else seemed to be directing the orchestra.

Which means in practice that we are never quite sure where we should be peering next, whether it should be at this, that or the other. Nor are we ever quite sure where the painting's focus of attention is intended to be. If that lovely, delicate, orderly genius Raphael had been tied to a chair, and obliged to stare at this work, he would, having elegantly thrown off his bonds and run out into the sun-blinded *piazza*, be howling at its anarchy.

The title might give us a small clue – as titles so often do – but in fact it does not. It seems to spit or to laugh in our faces. If this is indeed the Saviour of the World entering Brussels in the very particular year of 1889, how do we really know that this is the case? In short, where exactly *is* Jesus? He is the hero, it is his triumphal moment, but he seems to have absented himself. He appears to have lost himself in the crowd or to have become risibly indistinguishable from all the rest of

the teeming masses. The title itself is already comically jarring. When was Christ ever known to have chosen Brussels as a place to enter, then or at any other historical moment? What did Brussels ever mean to Jesus Christ? Which of the four Gospels has Jesus mentioning Brussels as a significant site of future pilgrimage? We ask these questions of ourselves even as we know them to be preposterous.

The next question seems to be unanswerable too. If this is indeed Christ entering Brussels, and we are expected to find him here, as the title more than suggests, where should we begin to look? Is there a particularly significant location within the anarchic, noisy, ever onward surge of this painting? Perhaps the most likely place is on that raised green platform to the right. There seems to be a master of ceremonies of some kind up there, red-pelicany-nosed, white-sashed, wearing a bowlerish hat, and carrying a pathetically thin, needle-like mace of sorts. But Jesus is not there, and we could argue that the way in which the crowds at the front of the painting appear to be milling and mingling amongst themselves rather aimlessly, flowing back and forth, might suggest that he has already passed on, and that this painting is nothing but the massively heaving, raggle-taggle aftermath of the surging crowd that came in his wake – and just missed him.

In support of this wayward conjecture – so much is wayward conjecture here – we could cite the cleric at the very front of the painting, almost dead centre, the one with his head thrown back as if offered up, John the Baptist-like, on a platter, who has the (fairly) vague look of Greek Orthodoxy about him, and who is clutching something – it is not quite clear to us what, though it could be the keys (or the key) to the kingdom of heaven – in his right hand.

Would not such a man be *near* to the Saviour, chaperoning him perhaps?

Wait a minute though. This wild, collage-like scene, the way in which everyone is juxtaposed with everyone else in these strange, roaringly slapdash and overlapping ways, makes us wonder whether this is indeed the hand of the cleric at all – if he is indeed a cleric and not a man in the carnival mask of a cleric. (That could be possible too. There is so much masquerading here.) Yet is it not too dark and too small to be his hand? But if it is not his hand, whose hand is it?

Oddly, almost as if in spite of itself, this extraordinary painting does cohere. It feels part-made from flattened fragments of itself, but it does proceed towards us, blaring away, all of a piece, big, medium and small heads, some lumpish, others rectangular, heads like pumped-up balloons or pitiful radishes, skeletal heads, clownish heads, frightening, galumphing heads, and all seeking out the absent Jesus.

# A
# Marvellously
# Shadowy
# Game of
# Prestidigitation

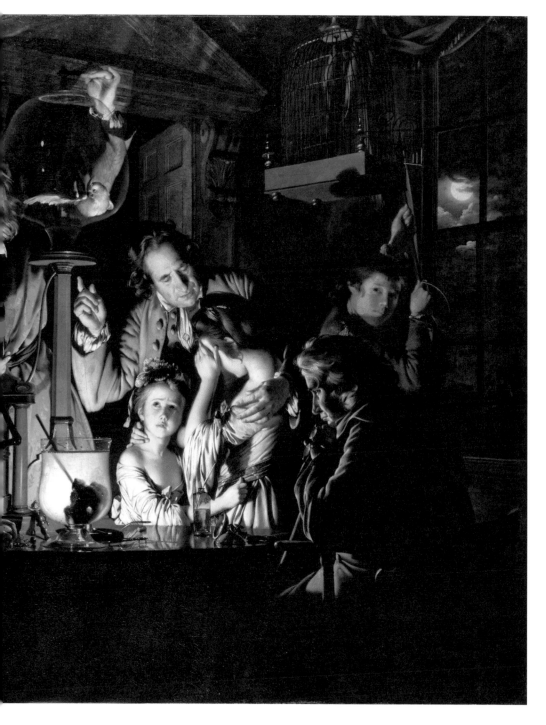

*An Experiment on a Bird in the Air Pump* (1768), Joseph Wright of Derby,
183 × 244 cm (72 × 96 ⅛ in.), National Gallery, London

Do we feel a certain coolness when we think about the eighteenth century? Well, we do often find ourselves praising it (or trying to define its nature) for what the head – and not the heart – achieved. Remember these time-honoured terms, for example: the Age of Reason, the Enlightenment, deism (in which the universe moves along, smooth as clockwork, without any need for the intervention of a personal god). Science was the newest deity. Did not the great poet Alexander Pope once write: 'God said, "Let Newton be," and there was light'?

This great painting seems to be alive with the tensions and the excitements of its historical moment. Its subject is the spectacle of science and how it woos the public – on this occasion that public is a prosperous family seen inside a well-to-do architectural environment, complete with panelled door, pedimented doorway, generous sash windows, a handsome console, and a beautifully made, highly polished table straight out of a contemporary pattern book, on the top of which a drama is being played out.

What exactly is this drama? A scientific experiment is being staged. A poor bird is suffering inside a glass chamber. In fact, it has fallen into a dead faint. It may even be on the point of death. The standing man who stares directly back at us – the only one who does so in this painting – is in charge of this bird's destiny. He is demonstrating the marvels of not-so-contemporary science in front of a captive audience.

He looks a little wild and charismatic. There is just a touch – in appearance at least – of the itinerant John Wesley about him. He is gorgeously tricked out in what to us resembles a velvet bath robe, which is itself held in place by a swashbuckling black sash. He could be an exotic merchant adventurer, this man who stands beside his

vacuum pump. The device (by no means newly invented in Wright's time) sucked air from a chamber, and demonstrated how a vacuum was created. The experiment had been conducted time and again – on larks, mice. This time it is the turn of a poor white cockatoo. The bird has plummeted to the bottom of the chamber. We see the scene at a moment of high drama. The lecturer is about to let the air back in. His hand is poised to do so. But will it be too late?

Wright was a great master of dramatisation through the use of light. In this case, the play of light reminds us somewhat of a mingling of van Honthorst, Caravaggio and Le Brun. Candle-light – where exactly is that candle though? – suffuses the scene, flooding and glossing each of the faces, some in profile, others full-face. Each face, each expression, is wonderfully particularised thanks to the use of this light source. Had this been daylight, the overall effect would have been much duller, much more generalised. We would not have found ourselves giving this degree of minute attention to each of these faces; we would not have noticed how each response is distinctively different.

Yes, just look at the fascinating range of responses, and see how they differ so dramatically from the youngest to the eldest. The youngest are fearful in the extreme – one of them cannot even bear to look at this poor, suffering bird – and the oldest (that seated man on the right of the table who leans on his cane) is the most steadily ruminative. And then, quite different again, there is the young couple who are standing to the left of the man who is the master of ceremonies. They are engaging in a bit of idle banter, aren't they? They are here because they are interested, but most of all they are pleased with each other, we feel.

Like a brilliant visual trick, the scene itself appears to have emerged from that darkness and, at the painting's outer edges, to be sinking back into it. The presentation enhances our feeling that what is happening here is a form of prestidigitation. Another lovely detail appears at the extreme right of the painting, near that boy who has his hand on the cord that might release the cage – should that poor bird ever need a cage again, and not a fresh scooped corner of the kitchen garden. Through the window we see a moon swimming through clouds. That detail adds a tiny pulse-beat to the atmosphere here.

# A
# Savage
# Witnessing
# to the Patient
# Application
# of Paint

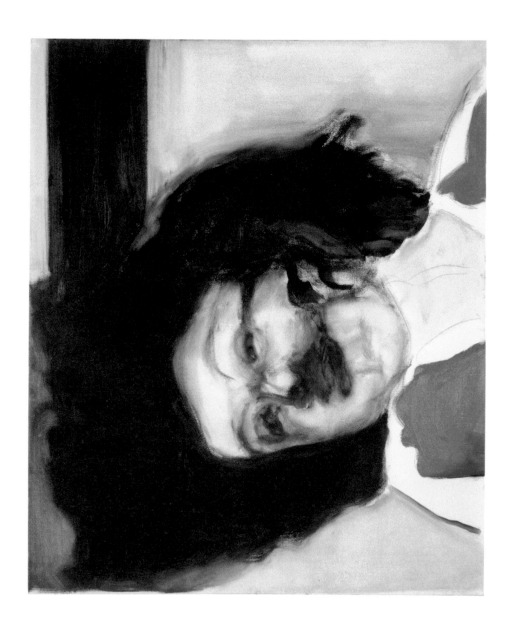

*Dead Girl* (2002), Marlene Dumas,
130 × 110 cm (51 ¹/₈ × 43 ¹/₄ in.), Los Angeles County Museum of Art

W e feel we want to reach out and swivel it, a quarter turn to the right, in order to set the image upright. Perhaps that would be a way of part-escaping, or, at least, part-mollifying, the reality, the terrible, no-holds-barred immediacy, of what this act of brutal painterly witness appears to be witnessing to.

Yes, it is the inescapable, struck-down, sideways-on-ness of this painting which both moves and horrifies. We seem to be looking down on it, to be a part of its tragedy, even as we look across at it. The head, with its smearily bloodied mouth, is being presented to us for our scrutiny rather as Salome presented the head of John the Baptist to Herod on a platter. It has been toppled, and it lies there in front of us like a dead weight (the swathing, the near smothering, of black hair seems to add to its ponderousness), never to be displaced from our memories. The head of John the Baptist on the other hand, though it is always, and undoubtedly, a brutally severed head (as this one is not), was usually treated with a degree of reverence by its painter. There is often little evidence of the kind of messiness that is generally in attendance when any head is severed. The primal savagery has been soothed away because religious sensibilities often seemed to require a measure of restraint. Not so here. Here savagery is the message, the content.

As with so many other paintings by Marlene Dumas, the painting itself has emerged from an image, torn from a magazine, kept for years in the artist's own personal archive, of a girl brutally killed. But there is much more than narrative content here. There are also the formal elements of the painting, and how they feed into our understanding and our appreciation of it. We could even say that the protocols of art are in contention with the brute urgencies of life, that the nasty, brutish

hurly-burly of the everyday has shouldered its way, side-on, into an art space. Take these colours, for example. The clash of two colours here – black in conjunction with red – define a reality, a mood, and appear to be encouraging us to think about the history of painting, how certain forms and certain colours work together, rhythmically. That bar of black which merges into the girl's hair puts us in mind of a characteristic gesture of the Abstract Expressionists – severe barrings of blacks and whites. The red is a pigment laid down in conjunction with other colours. It is also the red of arterial blood as it slow-oozes from a wound in all its alarmingly serendipitous shapelessness. And yet these vivid splashings of red are not in fact the red of her blood. They are the red of the top that she was wearing. The red of her blood, much darker and duller and greedily encrusted, is smudged around her mouth.

The painting seems to wish to draw attention to these two quite separate matters then: the painting as an act of making which consists of the putting together, the rhyming, the balancing, of certain formal elements, and the painting as an act of witness to the death of a youthful terrorist who had tried and failed to hijack a plane.

# From
# Squirming
# Rampancy
# to Perfect
# Composure

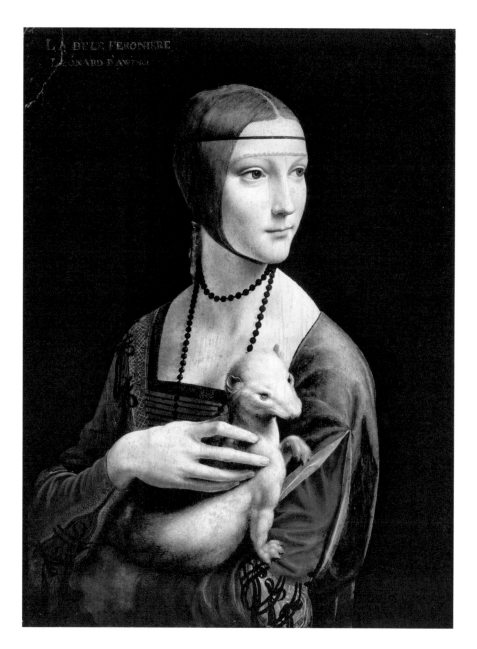

*The Lady with an Ermine* (portrait of Cecilia Gallerani) (1489–90),
Leonardo da Vinci, 54.8 × 40.3 cm (21 ⁵/₈ × 15 ⁷/₈ in.), National Museum, Kraków, Poland

This young Renaissance lady – more tricked out girl than lady – is cradling something savage, and this fact rather troubles us. Is she at ease with this creature? What is it there for? We think forward immediately to Hans Holbein's great portrait of a woman with a squirrel and a starling, painted almost forty years after this one, and we ponder upon the fact that Holbein's tenderly preoccupied red squirrel, also perched on the forearm, looked so much more benign than this perkily rampant creature, whose head is rearing up and away from the upper arm of this rather taut-looking young woman. And then we think of yet another artwork, a photograph this time, by the outrageous Robert Mapplethorpe, snapped in 1982. It shows a very cheeky old lady called Louise Bourgeois, half-cradling, half-trapping beneath her arm a giant penis called 'Fillette'. 'Fillette' her(him?)self was a work of 1982. What a smirk she has on her face! But is it appropriate to set these various images, hundreds of years apart, side by side? Is the lithe, muscular body of Leonardo's creature penile at all? Would Leonardo have gone in for this sort of a joke at the expense of a famous man whose court painter he would shortly become? Perhaps not.

And yet there must be more to this than a beautiful young woman and a risqué pet of sorts. Leonardo, being the subtle and clever man that he was, would not have been satisfied with a paucity of symbolic associations. Cecilia Gallerani was about fifteen years old and already the mistress of Ludovico Sforza when Leonardo, recently arrived in Milan, painted her. The familiar name of this painting tells us that this rampant, heraldic-looking creature is an ermine – which is, of course, a stoat in its white winter jacket. That name, 'ermine', lullingly bi-syllabic, sounds more precious and cherishable than the word 'stoat', which is

rougher, more cruel, more trenchantly out of doors, swifter with tooth and claw. Ermine fur was precious stuff, soft to the touch. Painters sometimes depicted the Virgin Mary in an ermine-lined cloak. There were also of course other beguiling tales swirling around this creature which Leonardo would surely have known and taken satisfaction in. The ermine lived in horror of soiling its winter jacket, it was said. In fact, it died if it did so. It was therefore regarded as an emblem of purity and even chastity. And so we easily shift from the idea of ermine to the idea of the purity of the young lady herself. She too was pure as the driven snow, hem hem. And then there is her own surname to take into account. Its first two syllables are the same as the Greek word for weasel or ermine...

Is this really only an ermine though? It looks more composite than that, as if Leonardo has assembled it from bits and pieces of other animals that he has been busy drawing over the years. The pleasing shock is to look from one to the other, from girl to ermine and back again. From the restless, squirming rampancy of the wild creature to the composure of the beautifully adorned girl. The girl's bony right hand, just a little larger than it ought to be, seems to be holding the creature back, to be pinching it in by the neck. How secure is its body, curled back as it is along her forearm? The creature looks heraldic, as if it is in part a device on a shield or a coin. It sprawls, strains somewhat. Its body seems to be swimming gracefully backwards, turning as it goes, against the thrust of her – again, slightly over-large – forearm. The girl, by comparison, looks perfectly self-contained within herself. She is the mistress of all she surveys.

Which is what, exactly? We do not know what it is that she is looking at askance, head twisted to the side, so intently, with just a hint of a smile. We admire the quality of her attentiveness. It is as if she is

being presented to us as a female model of perfectly settled intellectual engagement. Perhaps Leonardo is hinting at this: that such an intellect is well placed to tame the savagery that forever paws at one's sleeve. Has she spoken? Could she be about to speak? Those lips might suggest as much. The way in which her hair has been contained within, and curiously shaped by, no less than two thin veilings of fabric helps to define the near perfect shape of her skull.

# The
# Vast and
# Humbling
# Horrors
# of the
# Creation

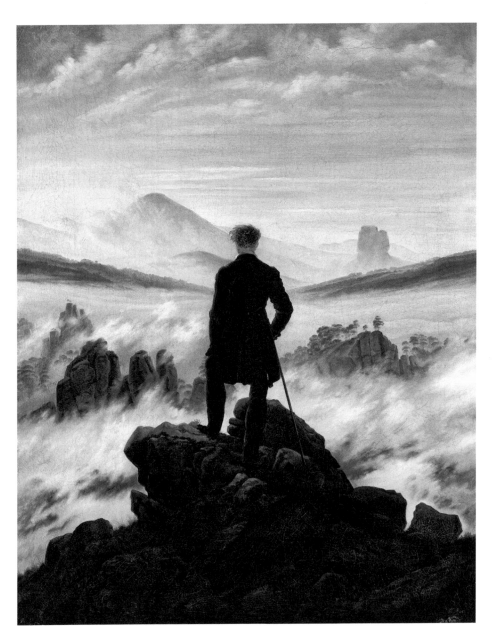

*Traveller above the Mists* (1818), Caspar David Friedrich,
98.4 × 74.8 cm (38 ³/₄ × 29 ¹/₂ in.), Kunsthalle, Hamburg

Call it the essence of the Romantic impulse if you like. Man, the eternal wanderer, stands alone in a landscape that he may be calling into being. He seems, with his cane and his frock coat, to be two things at once: the embodiment of the sheer imperiousness of man, commander and supreme explicator of the universe – see at what a great and commanding height he stands! – who may be orchestrating this scene with his cane as if he were the conductor of Mahler's Seventh Symphony, and also to be utterly vulnerable in the teeth of the overwhelming overmuchness of the forces of nature. He is both god-like in his stance and hopelessly overshadowed, vertiginous in his fragility and aloneness. Notice the unruliness of the hair on the top of his head. That is the only outward hint that there is wildness within.

He alone is nature's witness. Here he stands, on the very brink of self-knowledge and of a knowledge of this estranging – and self-estranging – Other that he can never know, except in part. (How can he hope to embrace that which he cannot truly see?) Perhaps the two are one. Perhaps this is what self-knowledge will in the end amount to... This is his burden. And his account alone will be its testimony. What he sees seems to give the lie to, and even render slightly ridiculous, his pre-eminent respectability. Beneath the trappings of his clothes, there is the inward seethe of his passions, intellectual or carnal, which are perhaps being perfectly reflected in everything that he is witnessing. There is no one to share all this with. The only dialogue will be this rumination with himself upon all that this means, which may include some reflection upon to what extent this scene is perhaps a showing forth of all that he knows or does not quite know about himself inwardly. Is what he is seeing some kind of reflection of the creative

turbulence of his mind? Is this the truth of the inner man? Or is he gaining some kind of inward quickening from all that he is surveying? How terrifyingly unruly and unknowable and untameable all this terrain is! How far does it stretch? How deep does it go? And what if he were to fall... We do not know – just as, we suspect, he does not know – what exactly it is that he is seeing, what this mirroring of the self may amount to. It is much more vast than this mere man posturing here even as he teeters at the very edge of the crag – in fact, he is a bit of a homunculus here, smaller than a man, against such a setting as this one. By even being here, we feel that he is presuming to outface or outwit or stare down – and all of these possibilities strike us as derisory. After all, and even though he may have chosen to come, he does not belong here. It feels absurd to have him here. He seems to have been wrenched out of his familiar social context, to have been beamed up to such dizzying heights as these, precisely in order to provide us with this image of self-estrangement. We feel that he stands here at a very unsettled moment in the creative process. Creation groans. The landscape seems to be billowing away from us even as we look at it with him, like the waters of an ocean rising and falling. How high are these peaks? How deep are the valleys that may lie beneath this dulling, muffling, blanketing mist? The seventh day is a long way distant, we feel. We do not know what we will see when the mist lifts. That is part of the painting's tension, that everything is yet to be revealed, and that we cannot quite believe that it will ever be revealed. Notice how the slope of his shoulder follows exactly the line of that distant blue peak, and how the mossiness of the texture of his clothing seems to blend, tonally, with the landscape. It is as if the shape of his own body and the fabric of his clothing are somehow complicit in this vast act of making. He is also perhaps contemplating the turbulent depths of the inner man, and reflecting upon the fact that there is no telling how far we can range if we apply our imaginative faculties to the utmost.

# A
# Dispassionate
# Act of
# Pure
# Vengeance?

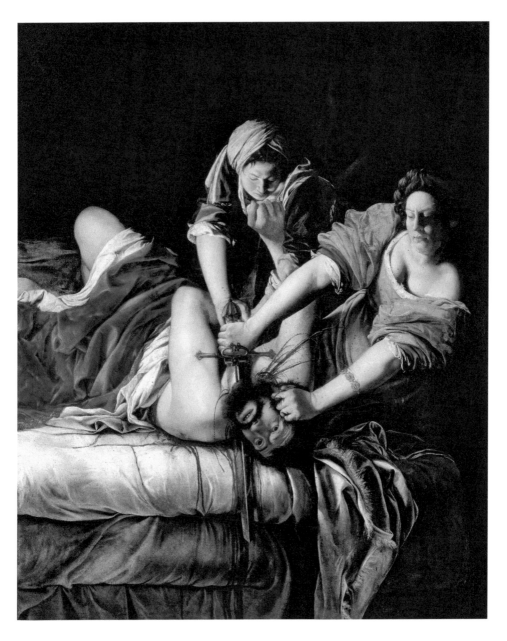

*Judith Slaying Holofernes* (c. 1614–20), Artemisia Gentileschi,
199 × 162 cm (78 ³/₈ × 63 ³/₄ in.), Uffizi Gallery, Florence

Even as we admire the overwhelming virtuosity of this seventeenth-century masterpiece, and luxuriate in the sheer magnificence of its painted surfaces – the warmth and fullness of those flesh tones, for example, the rendering of fabrics in crimson and gold – we also recoil in horror at the clinical brutality of its theme. It is nothing more nor less than the story of the studiedly brutal decapitation of a drunken, bearded man who appears to be conscious and horrifyingly witnessing – the eyes are open, the lips parted to reveal a gleam of teeth, the brow furrowed – to what is happening to him, even as his head is being severed from his neck (the sumptuous blade saws and slides, back and forth) by a woman, steely of purpose, powerful of arm, who is in the business of doing nothing other than exacting the final revenge upon him for who he happens to be: the general of an invading army. She is determined to take off that head at the perfect angle, expeditiously. This is why, with her left hand – see how her lower arm, at full stretch, has been spattered by a spray of blood from the neck – she must wrench that head back, and then to the side. Does she have hold of his ear to get the leverage she requires? The single most visually dramatic feature of the entire painting is that spray of crimson blood from the jugular, which seems to rhyme with the crimson of the fabric across his middle. See how the jet rises up in a firework-like curve of red, silken threads.

There are no visual diversions of any kind. The turbaned female onlooker, too, is utterly absorbed in the killing of this man, leaning forward, helping to hold the struggling body down, and as he suffers, so his right arm rises up and his fist seems to be supporting her chin, as if to encourage her to ruminate upon the scene – a particularly macabre supposition. There is a mighty entanglement of arms.

Other than this, the canvas is in darkness – in fact, the darkness seems to bear down upon the scene, enfolding it, as if to heighten its terrible theatricality. And in front of that darkness, as if set at the very front of the stage, there is this scene, lit so dramatically from the front in a way that can only be described as Caravaggesque. Who, as you may remember, was also a murderer.

Why though? Who is this anyway? The Book of Judith will tell us. Judith, a widower, lives in a city under siege by the Assyrians. One night she steals out with her servant Abra, dressed in her finest, to murder the Assyrian general, Holofernes. She is doing it at Jehovah's behest. This is the terrible act she is committing here in this painting, though there is no hint of any spiritual dimension. It is all a brutal tussle between a strong man and two equally strong and determined women.

Biography worms its way into this troubling story. Artemisia Gentileschi was one of four children, all painters. She was the most talented. The others were boys. She was raped by another painter. The rapist was pardoned by the Grand Duke of Tuscany. Ah, the amorality of aristocrats! Perhaps this terrible act has informed the way she has chosen to depict this theme. In fact, she painted the same theme twice. In the earlier version, the female assailant seems rather reluctant to commit murder. The Judith of our painting is going about her task with cold dispassion. Her rather unlovely face is set. What is more, she rather resembles the painter herself. That was not the case with the first version. What also rather shocks us about this painting is how such violence can take place amidst these lovely stuffs – the jewellery, the coverlet that is falling from the plumped mattresses of the bed. All this is redolent of high sophistication, not the brutal baseness of murder. How Janus-faced is man!

# The
# Preposterous
# Posing of
# a Bunch
# of Bananas

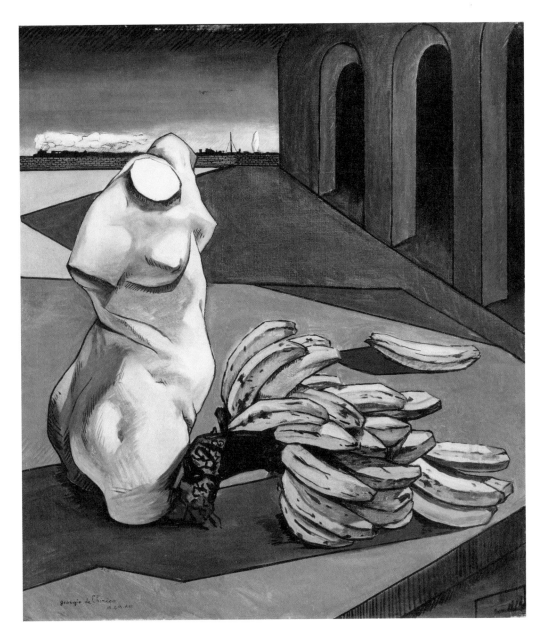

*The Uncertainty of the Poet* (1913), Giorgio de Chirico,
106 × 94 cm (41 ⁵/₄ × 37 in.), Tate Modern, London

The visually seductive, topsy-turvy world of unreason is so meticulously rendered in this painting by Giorgio de Chirico. Derangement has seldom been so crisply and so patiently expressed. This painting has such a studied air, as if the young painter – he was twenty-five years of age when he made it – has been observing the scene, with its ominously dark, raking, bizarrely squared-off shadows and ever receding horizon, dryly and minutely. There is such a painstaking attention to the issue of perspective, for example. Those flat planes of colour – the huge green plinth, the yellow (and what a shockingly bright Dijon-mustardy-yellow it is!) and the grey – are all laid down with such loving care, albeit somewhat flatly and brutally and definitively, as if they are so many bricks dropped onto an unsuspecting toe. I say issue of perspective quite deliberately, quite finically, because none of this makes any real sense. It all falls to pieces in the end. It is all a kind of not-so-gentle mockery of the idea of planes and perspective and all those painstaking attendant mathematical certitudes. It is all flats and stage sets really, lighter-than-air façades, behind which there perhaps exists an amplitude of ... nothing at all – just as there is nothing but a yawning blackness behind and beyond those yawning arcades.

Take those arches, for example. Look at the sharp edge of the vertical wall beyond the third arcade, right at the bottom, where it seems to butt up against that long and so meticulously painted low brick wall. Where exactly do they exist in relation to each other, this building and this wall? It is impossible to tell. They seem to have been manoeuvred into position with the aid of strong men and some mechanical gear. At first glance, they appear to be nudging up against

each other, but when our eye rises to take in the train hurtling from left to right (we are lucky to catch it before it steams headlong out of the painting) with its fanfarish gouts of streaming smoke, that train which seems to be speeding along the top of the wall – or perhaps it is being held aloft by some viaduct immediately behind the wall – we recognise that, surely, it is much further away from us than the end of the arcade. There is no way in which they could be close to each other. Or are we wrong about that?

But what of the foreground? What has the foreground to do with the speeding train or, to the far right of it, that white ship's sail – if that is indeed what it is – which seems to rise up from nowhere like a flaming white plume? (Yes, we conclude, when we spot that sail, that perhaps there is a sea or a river behind the viaduct which may or may not be behind that wall after all.) What have a ship's sail and a speeding train to do with a headless, armless, legless classical statue, which is making a tragic twist in our direction, as if exhorting us to acknowledge her grief?

But wait a minute. There is something else here. There is the largest bunch of over-ripe bananas which has ever been seen in a painting in the Western tradition in the company of a headless classical statue and a speeding train and the small flaunt of a ship's sail. Are these bananas some kind of a gross penile joke? Are they not too big for their own skins? Why should bananas be allowed to strike such a pose beside an example of classical statuary? The fact that the classical statue – a note tells us that it is Aphrodite, she who once emerged from the froth of the ocean – is set in conjunction with a bunch of bananas transforms this section of the painting into a kind of still life. (Yes, we have often seen, and especially in the Renaissance, paintings of brimming bowls of fruit and flowers beside statues of the pagan gods.) And yet the whole

point of a still life, surely, is that the elements are *perfectly still*, whereas we are not entirely sure that this particular statue is quite still enough. In spite of the fact that it has lost its head, it looks altogether too fleshy, and too much in twisty motion, for us to be entirely convinced that it is made of stone. If we pricked that buttock, would it bleed?

Yes, the entire painterly escapade is utterly preposterous, which is what the poet Wendy Cope evidently decided when she wrote her own poem entitled 'The Uncertainty of the Poet' in mock-homage to this painting. This is how that poem begins: 'I am a poet. / I am very fond of bananas. / I am bananas. / I am very fond of a poet.'

Ah yes indeedy.

# A
# Menacing
# Quartet
# of Merciless
# Leerers

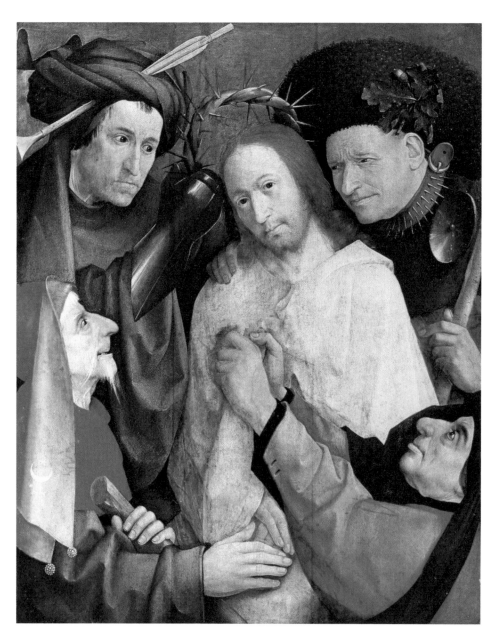

*Christ Mocked (The Crowning with Thorns)* (1490–1500),
Hieronymus Bosch, 73.5 × 59.1 cm (28 ⁷/₈ × 23 ¹/₄ in.), National Gallery, London

This is an unnerving, uncomfortable painting, and what is more it is rather uncharacteristic of the Hieronymus Bosch with which we thought we were all so familiar. We remember so well, don't we, from the prints of our student days perhaps, all those hellish visionary scenes, set in fantastical landscapes, pullulating with tiny figures, swarming up ladders, upended in barrels, demons and men, in the company of grotesque instruments of torture?

This painting, by contrast, is a relatively small-scale devotional panel, oil on oak, which invites us to meditate upon – and learn from – Christ's suffering in those final hours before his crucifixion. For once, the five figures are writ large, huge in the picture space. There is nothing but these figures, and each face, though inclining towards caricature (yes, is not each one of them more than a little like an animal? Is not the man at bottom left, for example, who stares up with his spiky goatee beard, as goatish as they come?), is very carefully and individually characterised. And then there is that wonderful, throttling, buckled, ruddy collar whose spikes seem to be in earnest conversation with the spikes of the crown of thorns nearby, worn by the malign, narrow-eyed tormentor in the wonderfully flamboyant fur (or astrakhan) hat at top right, a hat which sports an extraordinarily generous sprig of oak, so meticulously rendered that it could be a small and exquisite still life in its own right. This collar looks as if it would be more fitting around the throbbing gullet of Del Boy's mastiff as he walks the sink estate at twilight, panting for his life.

What is more, it feels as if these tormentors have all been pushing their way in, so desperate are they to be included in this scene of ritual humiliation of a terribly meek and compliant man. If the painting had

been glazed – which it is not, I must hasten to add – it would surely have been fogged by their hot, rancid breath. In fact, so great is this sense of crowding menace that we almost feel as if we too are being pushed, jostled up towards it, from behind, as witnesses to Christ's torments at the hands of the Roman soldiery. Roman soldiery though?! Surely not. Well, Roman soldiery in sumptuous contemporary dress perhaps. And yet not even that. These men, tricked out in their startlingly colourful clothes – Bosch seldom goes in for such high colours – look more like scheming, prosperous merchants than soldiers. Look again at those two wonderful hats, for example, to left and right at the top of the painting. The hat on the right, with its grandiose sprig of oak – that acorn in its cup winks at us as if it were solid gold – is as affecting as the rings of Saturn. Well, almost. And then there is the equally extravagant hat worn by the man to the left – would soldiers have worn such headgear to be stepping out in? – which is all green folds and pastry-like twists, and is pierced, with an almost brutal degree of efficiency, by something that closely resembles an arrow which happens to be just missing the skull. This detail is a delight in itself, demonstrating how the decorative makes playful reference to the martial. Ditto the concave, disc-like, shield-like brooch attached to the coat of the man opposite.

Unnerving, I said. An example of extreme bullying, you might even add. Yes, because it is all so studied, the presentation of the theme of this painting, so full of brute determination. It shows these men getting on with the job in hand, and having nothing else on their minds. They are almost mechanised, these encircling brutes, as if they are not so much men as extensions of the staves that they are wielding with such care and attention. The torture is beginning to happen, this is where we catch the scene, and it is a snatched moment that we are seeing,

temporally extremely abridged. This is why the tension is so heightened. The horrible crown of thorns (and can there be a nastier-looking crown of thorns than this one? Can thorns and crown ever have looked more menacingly and ruthlessly metallic than this one, ever so long and so sharp?) is being lowered home on to that small head with its brilliant, though slightly lank, auburn hair. We wince even as we look at it. And, to drive the point home, it is being lowered into place, oh quite slowly, we feel – because that is how the best and the most sadistic torturers work, slowly and precisely – with the aid of a massive mailed fist, which gleams so dully black, and also shines reflectively. This fist, such is its shape, scarcely looks human at all. It looks a little as if it might have come out of a painting by Wyndham Lewis of mechanised soldiery.

Yet, most of all, we are here to observe Christ, that meek-eyed man at the centre of this menacing quartet of leerers. They all look at him with a gluey degree of voracious and utterly unloving attention. But Jesus, unlike all the rest, appeals beyond the painting. He looks out, head lolling, sporting a rather wispy tache and unmanly ginger beard, beyond the picture frame, and directly into our eyes. He engages us. He invites us to be at one with him at this moment. His skin is so strikingly, strangely pallid, we notice, as is the garment that he is wearing. Yes, he is pale, resigned, and utterly unresisting. He has turned the other cheek. Meanwhile, there are hands everywhere, so many of them, in this painting. We could think of it as a swarm of hands, nine of them in all, touching his knee, bearing down upon his shoulder, and a full two rending his garment. Such nasty, enveloping hands.

# The Steady,
# Full-Frontal
# Solemnity
# of the Jesus
# of His Day

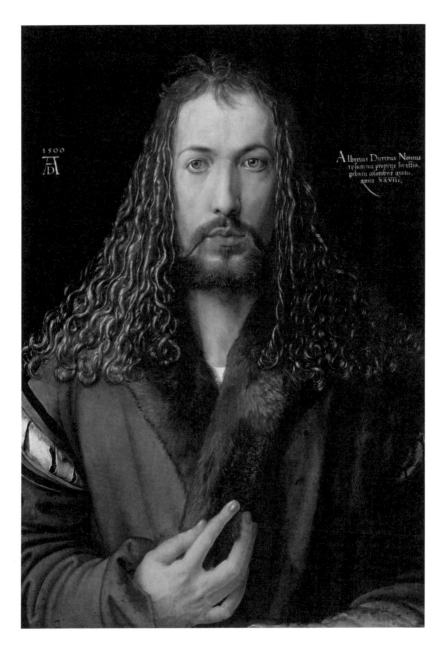

*Self-Portrait* (1500), Albrecht Dürer,
66.3 × 49 cm (26 ¹/₈ × 19 ¹/₄ in.), Alte Pinakothek, Munich

Let us begin by translating Dürer's own, self-penned Latin inscription, which is so skilfully aligned with his monogram, that A protectively enclosing and scaffolding the much smaller D, and all topped by the year of the painting's execution, which, given that it is exactly halfway through a millennium, sounds hugely significant. (Had we known the month and the day also, it would have been far much less of a blast upon a trumpet.)

Set against this severe black ground – the image appears to need no homely context – it is an announcement both florid and grave, and (who knows?) perhaps of some symbolic significance too. In short, no slick advertising man, of our day or any other, could have improved upon it.

Taken together, these elements seem to suggest that this portrait, and the man who painted it, might be pivotal in some way. And so it proved to be. Dürer's hubris, his vaunting self-confidence, were not misplaced. We have not forgotten him. Date and monogram are skilfully positioned to the left of the head, and the inscription to the right. Monogram and inscription are on a level with his eyes, those windows of the soul. We look directly into those eyes. His extraordinarily level gaze transfixes us, as if on a meat skewer. The head is long and columnally assured in its verticality. There is a general suffusing of warming brownness, almost everywhere you choose to look.

These few words in Latin, so cool and so calculatedly sober, will tell us, in part at least, how he wanted his self-portrait to be viewed: 'I, Albrecht Dürer of Nuremberg,' it reads, 'portrayed myself in everlasting colours aged twenty-eight years.' How young he is to be seeming so old and self-assured! And what a charged adjective to be

using of these colours that he has chosen: 'everlasting'. That is how long the Deity survives, is it not, from everlasting to everlasting? So Dürer is raising his own status, mightily, to be using such a word of those colours of his. And yet there is more than this. It is not only a matter of hue. It is also a question of who exactly Dürer has chosen to resemble. No less a being than Jesus himself, surely.

What we have here is an image wrested from the ghost of an ancient icon. This is a secular painter making reference to himself as Christ the Ruler of the World. Does not that gesture of the right hand almost remind us of the gesture of Christian blessing? So is this young man claiming powers of creativity akin, in their near miraculous comprehensiveness, to those of the second person of the Trinity? Is that why, with these streaming, almost gilded rivulets of ringlets, he is playing at being Jesus in all his steady, full-frontal solemnity? And yet, even as we are almost inclined to pay homage, something gives us cause for deep unease. Would Jesus, that man born in the stink of a stable, have really tricked himself out in a garment of such brazen opulence?

# Such an Engorging Emblem of Shapeliness

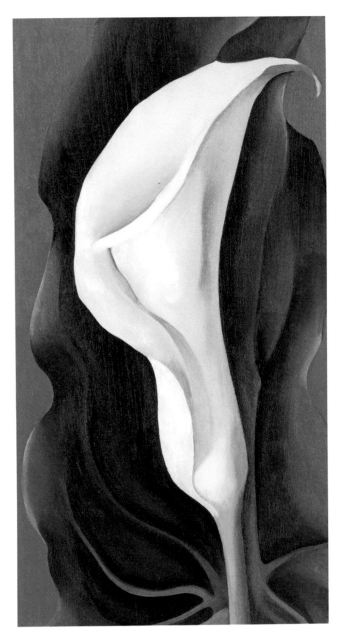

*Single Lily with Red* (1928), Georgia O'Keeffe,
30.5 × 15.9 cm (12 × 6 ¹/₄ in.), Whitney Museum of American Art, New York

The point about flowers as they were so often painted by the great still-life painters of, say, the seventeenth century in Holland is that for the most part each flower was one amongst many. No flower was a self-preening individualist. No flower said: look at me in all my separately seductive gorgeousness, passing stranger. Each separate bloom belonged to a great cascading of colour, a marvellous tonal agglomeration, a huge, peacockishly fan-like shapeliness.

What is more, it is the fact of the pleasing generality of those scenes (which may well have included a brace or two of dead birds – paintings are odour-free) that not only engages us, but also made paintings of that kind so saleable to those art-thirsty Dutch burghers in their heady state of prideful, newly won independence. Each flower was one amongst many, and each one was relatively – yes, relatively speaking – small. Each one belonged to a kind of chorus line of flowers. There was no star turn. What is more, most of those kinds of paintings were wholly morally unexceptionable. They could hang anywhere. There was nothing to cause offence. Children were not corrupted. Flowers were nothing but flowers: beautiful, and extremely pricey when rare indeed. In short, they were a matchless export, painted or not.

Now look at this painting by Georgia O'Keeffe, painted in the middle of the 1920s. The rules have all changed. O'Keeffe believes in flowers as individuals – and individualists. She wants them to strut their stuff. She wants them to be more than they often seem to be when offered, awkwardly, by a man (by way of apology for a long, hard night) in their crinkly-papered bunches. Just look at the comeliness, the singular shapeliness of this lily. It seems to want to stretch so tall in order to remind us of the full extent of its beauty. You could call it

balletic in the way that it yearns almost to fling itself backwards against that luxurious-looking ground of rich green leaf, set against an even richer red. Those background colours enhance the sense of the flower's own singular presence amongst us. They make it seem even more precious than ever. In fact, this particular variety of lily was not especially rare or precious amongst blooms – sometimes it was even despised.

Here it is a shockingly forthright presence, looming particularly large, as large as it would be if an insect were to be ogling it. And, yes, that is exactly our perspective as we look at it, peering just over the brim of the cup of its calyx, though not very far. We are more bees than human at this moment. Its size almost overshadows us. It looms over us, almost menacingly. We feel almost stiflingly close up to it – and this sense of our proximity is enhanced by the fact that we do not see the flower and its partially enclosing leaf in their entirety. We have zoomed in too close to see everything, and by choosing to represent it in this way, O'Keeffe has also, simultaneously, slightly reduced the degree of realism. She has nudged the flower, though authentic enough thanks to its sheeny, almost tackily waxy presence, which is so lovingly and painstakingly rendered, in the direction of a more generalised emblem of shapeliness. She has also emphasised its anthropomorphic qualities. We could even argue that she has nudged us into looking at it as a partial representation of the luxuriously clothed female body, presented to us partially enveloped by that cloak-like green ground. Let us not push this analogy too far though. O'Keeffe responded furiously when her critics grossly sexualised her flower paintings. So let us stop at that.

# The
# Uncanny
# Watchfulness
# of the
# Imperial
# Oppressor

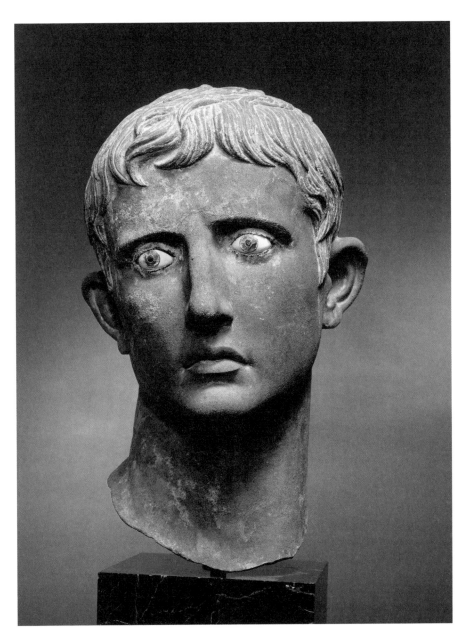

*The Meroë Head of Augustus* (27–25 BC), unknown artist,
46.2 × 26.5 × 29.4 cm (18 ¹/₄ × 10 ³/₈ × 11 ⁵/₈ in.), British Museum, London

Great museums, like Imelda Marcos' splendidly toothsome collections of shoes, are always a bit too overwhelming. The trick is to proceed, at speed, to a single object, and then stop. Here, for example, is a single object from the overwhelming richness and eye-teasing diversity of the British Museum. It is a single bronze head, in a truly remarkable state of preservation, and it is usually displayed in a dramatically darkened interior. Raised up on a plinth inside a vitrine in the centre of the room, and somewhat larger than life (yet not so large that it fails to have designs upon each one of us), it is cannily underlit. The height at which it is presented to us suggests that, were the body to continue down and down (as it does not), we would be facing a man of a little under seven feet in his Roman sandals. The effect, well judged, is mildly overawing. It is surprising quite how phantasmally present an absent body can prove to be.

This head of Augustus Caesar, the spoils of a revenge attack upon the might of Imperial Rome by the king and queen of Meroë and their North African armies, is one of a multitude of representations of the man who created a great empire, just a couple of millennia ago, from a muddle of warring provinces, and transformed Rome itself from a stinking warren to a spacious city of marble temples, reeking with pomp and self-congratulation.

Meroë, capital of the ancient Kingdom of Kush, was a far-flung outpost of that empire, and the victors buried the head, quite shallowly, beneath the steps of a shrine erected to celebrate that great victory so that it would always be stepped upon when worshippers entered. A pleasing ritual of humiliation, you might say. The head had been

wrested from its body, and it was re-discovered only in 1910. Grains of sand still adhere to its surface.

Augustus Caesar, the divinely anointed heir to Julius, was a small man with carious teeth, widely spaced, and bad skin. He had some sort of bodily deformity. He also possessed extraordinary eyes, and this head is worth seeing for the sake of those eyes alone, which are fabricated from wedge-shaped, almost suckable lozenges of highly polished white limestone. Now this statue would have been reproduced again and again in order to remind its global citizens that the ever watchful Augustus was always within breathing distance of any potential dissident. These eyes, on the other hand, so snugly fitting, uncanny, piercing, and brilliantly white, were the work of a single particularly talented fabricator. Admire the tiny pods of red which mark the tear ducts, or the remnants (sadly, they are nothing more than remnants) of the copper or bronze eyelashes. The head itself appears to look slightly askance, as if, at a turn of the bullishly muscular neck, its stare might just have happened upon some cowed observer. It is youthful, restrained, composed, resolute and ridiculously idealised. It harks back to the Greeks. The hair consists of snake-like slitherings. Its presence here looms down upon us like a guilty conscience.

This image was still being used at the end of Caesar Augustus' reign, when he was seventy-five years old. Perhaps all dictators possess a timeless, fear-inducing vigour in the haunted memories of the oppressed.

# The Dance
## of the
## Prestidigitatory
## Image-Maker

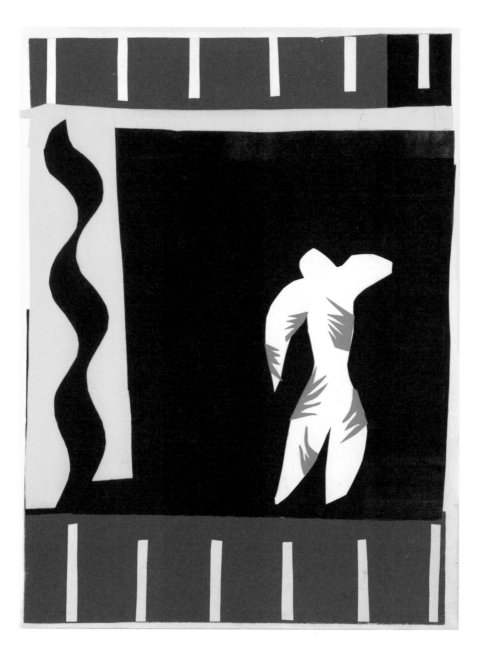

*The Clown* (*Le Clown*) (1943), Henri Matisse,
67.2 × 50.7 cm (26 ½ × 20 in.), Centre Pompidou, Paris

To be physically constrained can also be liberating. De Kooning made some of his late sculptures with his eyes closed. Titian's extraordinarily loose brushwork in some of his late paintings may, in part at least, have been due to failing eyesight. In his final years Matisse, less and less able to paint, and often confined to a wheelchair, began to do something that every child loves to do: to cut shapes out of paper and organise them – or have others organise them, at his bidding – on flat surfaces. The walls of his studio, for example.

On the opposite page you will see a plate from one of the greatest examples of a *livre d'artiste* ever made. The book is entitled, rather misleadingly, *Jazz*. Its subject matter has nothing to do with jazz at all – except that it would be possible to argue that its improvisatory quality is a tad jazz-like. Matisse by no means regarded the finished book as an unqualified success. The flatness of the printed page displeased him. When he made cut-outs, early or late, he always sought to preserve some sense of layering, and the smooth surface of any printed book does away with that entirely. The book's plates range around in theme: from the circus to classical mythology, for example.

When the project was first under discussion, the plan was for Matisse to illustrate – if that is not too banal a word by half – a selection of poems. In fact, his images are now complemented by his notes, written in his own hand, which seem to well up from the depths of his own lively anxieties about making.

This gouache has such simplicity – its organisation looks and feels almost inevitable; we swim in its lightness – that we cannot but gull ourselves into thinking that it arrived fully formed. The scissorings

are sharp and swift. It feels like a near perfect enactment of the predicament of the clown – or the predicament of the artist *as* clown, which we have seen, time and again, in works by Domenico Tiepolo, Picasso or Sherman. The body, spot-lit a ghostly white against the circumambient darkness, has been savagely, exuberantly fingered with red, as if to kick-start us into a combination of shock and laughter. Its posture – that very particular, slightly exaggerated lean – is both tragic and comic simultaneously. The white against black feels crisply lonely. The figure keeps company with severe vertical barrings – a circus animal's cagings? – and that lovely piece of rising black sinuosity on the left, which is snake-like, smoke-like, and certainly prestidigitatory. It is a book full of dancing images, each seeming to catch at the tail of the last.

# The
# Blakean
# Sun God
# Bursts Forth

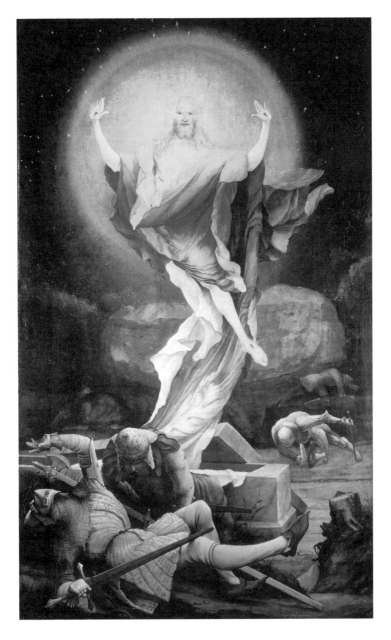

*The Resurrection of Christ* (c. 1510–15), Matthias Grünewald,
panel of the Isenheim Altarpiece, 269 × 141 cm (105 ⁷/₈ × 55 ¹/₂ in.),
Musée d'Unterlinden, Colmar, France

**M**atthias Grünewald, in this panel from his great Isenheim Altarpiece, has taken outrageous liberties with the story of Christ's resurrection from the dead on Easter Monday. Try as you might, it is impossible to find in any of the four Gospels an account of the very moment when Christ comes alive again against all the odds. The story of his disappearance from the sepulchre, piously gifted to him by Joseph of Arimathea, is always told a little after the event, to incredulous incomers, a piece of extraordinarily newsworthy reportage, perhaps communicated by some angel: that the Master was there, the stone was rolled away, and he rose again...

This panel is so dramatically different from the rest of the altarpiece, whose central painting shows us the suffering of the Crucifixion in all its spare and lurid tragedy – Christ's distended ribs could be a macabre instrument to be played upon. Grünewald seems to hurl all caution to the winds in what appears to be an almighty shout proclaiming the triumphal emergence of some Blakean sun god – see how he seems both to be appearing from and dissolving back into that sunburst of a giant halo, which frames him in a tondo of light, pushing him forward, presenting him to us as if against a glowing golden platter. The stars in the black night sky look to be dancing attendance upon him in their wisps of pretty patterning. It is as if his entire upper body glows molten. The figure looks airy, diaphanous, balletic, as if swollen with the dazzling light from some glory hole.

See how he presents his two palms to show off the wounds. Yes, it is all true, those emphatically bloody wounds seem to say. They killed me and I fought back, being the unstoppable incarnate deity. He floats so easily. His wind-blown robes, scarlet as a reminder of his bloody ordeals,

and a fetching yellow to match his gorgeous corn-yellow hair, buoy him, boyishly, springily, leapingly, aloft. Yes, he has leapt or burst, single-handed, out of that heavy, confining tomb. The massy stone of its thick lid has been displaced, and he has risen up out of his own streaming and unravelling grave clothes, leaving them to fall away beneath him as he rises. They still attach themselves to him, umbilically, as if to prove that what once was earth-bound is now free of such chains.

There is such a difference between the way in which the risen Christ is depicted, almost on points in white tights, and the heavy, earth-bound soldiery, who lie in a tumbled heap, as awkward as he is awkwardless. As if to emphasise the fact known to us from the Gospels that no one saw the newly resurrected saviour of mankind at the moment of his resurrection, the spilled bodies are all turned away, heads slumped forward or wrenched awry like over-stuffed, over-embellished puppetry. Only we are privy to the miracle of his dramatic and triumphal re-appearance.

# The
# Ravishing
# Allure of the
# Provisional

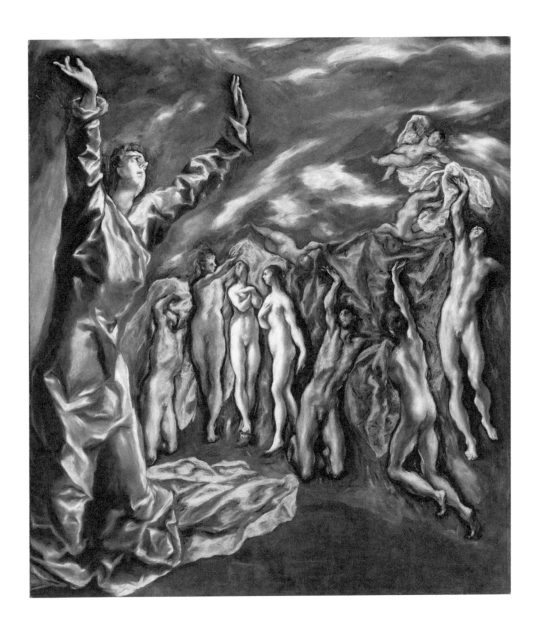

*The Vision of St John* (1608–14), El Greco,
224.8 × 199 cm (88 ¹/₂ × 78 ³/₈ in.), Metropolitan Museum of Art, New York

Paintings can remain unfinished for so many different reasons. This very fact turns them into sources of enigma. The possible causes of their abandonment are so various. Death may have intervened, or it may have been something as prosaic as a more pressing commission. The artist may have hit a block of one kind or another. A patron may have cooled. In the case of many of the late canvases of J.M.W. Turner, we simply do not know whether the present condition of these works was intentional or not. He often didn't tell us. What we do know is that he was quite regularly in the habit of resolving a painting at an almighty rush, over a single feverish working day. His admirers (and cowed detractors) could then witness the awe-inspiring spectacle of the master wresting something from nothing – like God busily at work on his creation. In the seventeenth century, it was not unusual for an artist to complete a painting in part, and then to wait for a likely purchaser to express an interest in it before completing it – perhaps at an indecent speed. We may never know why this painting by El Greco was left in his studio at the time of his death. What interests us just as much is its afterlife.

So much that happens is the play of accident. At the turn of the twentieth century, El Greco's reputation was at last on the rise and rise, having been moribund for centuries. Why take seriously an eccentric mediocrity? Little by little, opinions changed. Degas saw something very special in him, as did Rainer Maria Rilke, the great poet and sometime secretary to Auguste Rodin. He seemed to be one of us after all. The intensity of El Greco's colours, his oddly elongated forms, that wild, visionary gleam in his eye – all these factors helped to turn him into a precursor of modernity.

Pablo Picasso saw this monumental altarpiece, commissioned for a church just outside Toledo, in the studio of a Spanish painter friend in 1906, and it quickened something inside him. It also kindled an urge to express the idea of the Spanish soul. What is more, and more specifically, it had a profound influence upon the painting which became known as *Les Demoiselles d'Avignon*. What Picasso might not have guessed is that the fact that this altarpiece is probably unfinished has invested it with qualities that it might not have possessed had it been polished to a higher level of perfection.

The subject is taken from the Revelation of St John, the final book of the New Testament. The evangelist himself, standing on the extreme left, seems to rise and rise out of his own shimmeringly columnar body, as if aspiring skyward. His fingers seem to be pushing the paint around as if to assist in the artist's wildly turbulent execution of the sky. Huge bolts of cloth, green, yellow and pink, are in writhing, rippling motion, as if they are almost alive, as if they aspire to that condition of protean shapelessness possessed by water. Seven naked figures claw at and reach out towards this cloth. What exactly is it though, and what purpose does it serve? The text describes how robes are given to the souls of those who have been killed for the Word of God. You could therefore call this altarpiece a species of consolation to the faithful.

The moderns would have admired the fact that there is something very rough and ready about this painting. It is all no-holds-barred, rushing, provisional gesture, something caught on the wing. There is no heightened polish here, no solid, utterly dependable, old-masterish, browny dullness of the kind that Joshua Reynolds so strove to emulate with his treacly, undryable bitumen. The spaces are ill-defined; distances are fantastical; issues of perspective have been blown to the four winds.

It is the compelling atmosphere of this work that seizes us by the scruff though. This painting looks molten to the touch, as if it is still being made. And this is precisely what we too, latter-day moderns all, like so much about it. We want paintings to look provisional – think of the canvases of Peter Doig, finished enough but never too much. We want to be reminded that paintings are made things. Old-fashioned illusionism feels too pat, a species of fakery. So there is much flatness – or near flatness – here. These gesturing, naked bodies, those sky-turning, sky-tumbling, backwards-somersaulting, putti-like angels – surely they are no more than three-quarters done. Entire mouths, hands, chins are smoothed away – or are left unpainted. It is as if we are seeing them through a fudgy mist of intense light, the light of the visionary moment, just before everything becomes clear. We like this feeling of being on the cusp of revelation, amidst bodies that seem to be moving towards their full identities, their full shapeliness. What is more, the whole thing was brutally trimmed down during its 'restoration' in 1880. A whole section of the upper sky was removed. Good, we think to ourselves. Yes, we quite like how that sky seems to be closing in on the squirming fingers of St John. Unstillness can hold such an appeal.

# The
# Unsettled
# Wrenching
# Awry of the
# Human Form

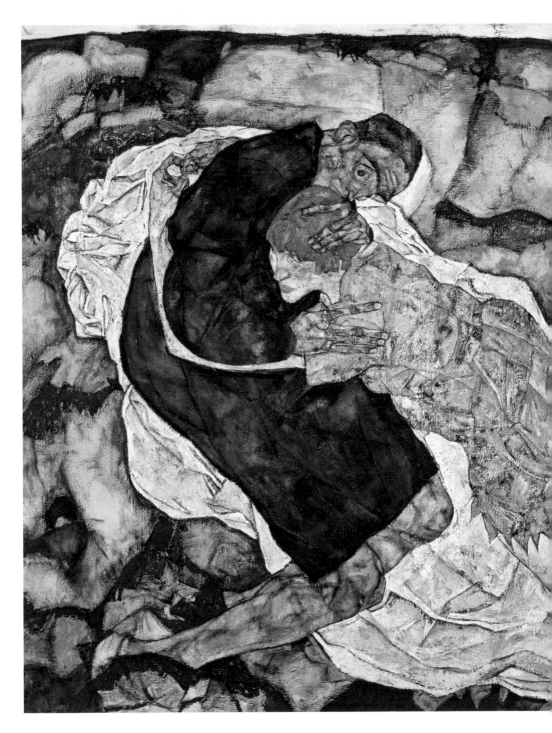

*Death and the Maiden* (1915–16), Egon Schiele,
150 × 180 cm (59 × 70 ⁷/₈ in.), Österreichische Galerie Belvedere, Vienna

We seem to be watching from above, at a high vantage point, as if from a helicopter in a war zone. The painting turns beneath our gaze, clockwise or counter-clockwise, as if our eye might be the pin at the centre of a Catherine wheel. At first, the overall effect seems to be one of brilliant patterning. The shapes of the two central figures, desperately clinging and cleaving, so utterly dominating, appear to mimic the shapes of the hill-like forms which both surround them and seem to press forward and into them from behind. The shape of the woman's buttocks is akin to the buttocky roundedness of those hill shapes. The long rising curve of the man's back seems to mimic the idea of the upward rising of some great geological formation. That back is the world in its primal making. The two of them, utterly bonded and at one in their aloneness with each other, are afloat above those hills, on that rucked fling of white fabric, as if this is some kind of a dream of what is happening to them. Is this a tragic clinging to life's only certitude: death?

The painting also puts us in mind of the circumstances of Schiele's own life at this moment. He is on the eve of conscription. Perhaps then the mood of this painting is being tainted by the thought that he is being spirited away into the arms of death. He has also just chosen between two women in his life, with great callousness. One he has married, the other, a model of long standing, he has abandoned. There is therefore a tremendous tension about all this clinging and cleaving. The figures themselves are pure, distilled essence of Schiele: that slightly awkward boniness; the tapering fingers. Schiele's human bones often tend to look twiggy, over-extended and even badly assembled, as if they might all of a sudden fall apart at the mighty clap of God's hands.

There is often a strange wrenching and writhing about the way in which one relates to another, as if nothing will ever be settled. He was often inclined to paint or draw human beings in pairs, writhing around and through each other like reptiles. After his marriage, his portraiture began to look more calm, more serene, less tortured, the human body itself a more wholesome subject altogether, less clinging to life as if to the spar of a boat in mid-ocean. Not so here. The embrace here is a strangely unsatisfactory one: repulsion and embrace all in one. Perhaps it is more a matter of necessity than desire. No one can outlive the claims of death.

The man's stare is blank and wild, disinterested, otherwhere engaged – look at that distended pupil. With the long and bony fingers of his left hand he appears to be caressing, as if dispassionately evaluating, the dome of the woman's skull. The impulse of the other hand appears to suggest that he may be repulsed by the way in which she is exaggeratedly enwrapping him with the long curve of her left arm. That curiously long arm of hers is rendered all the thinner, longer and stranger-looking by the fact that the sleeve of his coat part-conceals it. Her fingers – are they loosening their grip even as they embrace him? – are turning and twisting about. We have noticed that he appears to be disengaged from this embrace – even though it is everything that is happening here. She too looks askance, into the middle distance. There is no pleasure in that look of hers. Meanwhile everything behind and beneath them, all that agitated landscape, seems to be engaged in a kind of heaving, in-and-out breathing, erotic dance of sorts, coaxing the two of them into a dance of death. In this case, the last dance with death perhaps. Or the last dance with the jilted or jilting lover.

# The
# Mirroring
# of the
# Mysteries

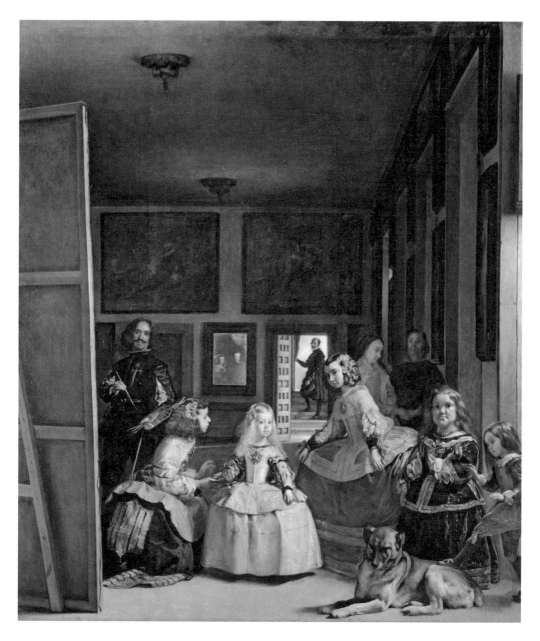

*Las Meninas* (1656), Diego Velasquez,
318 × 276 cm (125 ¼ × 108 ⅝ in.), Prado, Madrid

We know so little about Velasquez the inner man. He left no memoir of his life. He was the soul of discretion – which would have been pleasing to Philip IV of Spain, who employed him as court painter. Velasquez painted him again and again in all his miserably inbred Habsburg weakliness: that thin-boned, tapering chin; the tallowy skin, etc. The court painter – he held the post for much of his life – was evidently a man who could be trusted with a secret. And this painting, too, in spite of the fact that it seems to offer so much up to us, and so richly, is the soul of discretion as far as its meaning is concerned, and therefore a perfect embodiment of the hand which created it.

We are deep inside private rooms of the royal palace, watching a bit of local ritual, as the painter, Velasquez himself, paints, on a monumental scale. What is he painting? That we cannot see. Instead what we witness is the huge, rearing mystery of the wholly unenchanting back side of the canvas, with its wooden supports, set against an easel. An entire world of illusion, stroke by stroke, is coming into being. What exactly is he painting though on that canvas? Is it this scene that we are ourselves witnessing? Possibly. Now the interesting conundrums begin. If that were to be the case, would the painter not be looking at it in a mirror? Is he not in fact painting what he sees reflected? His gaze might suggest as much. And then it gradually dawns on us, that we, the onlookers at this great spectacle, are ourselves the mirror into which its large cast of characters are gazing with such fascination. Because mirrors are always fascinating in so far as they show us ourselves, as if objectivised, and we are always pleased to examine the subject of ourselves, to see how we are measuring up, day by day, in the icy cruelty of the mirror.

Here it is a mightily democratic crowd which stares into that mirror's surface. The title would suggest as much – it means 'the maids'. These maids are fussing over the young Infanta, the king's daughter, offering her water from a brown ceramic jug of the kind that Velasquez used to paint so lovingly, as an extraordinarily precocious teenager, on the streets of Seville, his home town. He had a lot of feeling for the poor. This, on the other hand, is an upstairs/downstairs scene. That dog looks almost as splendidly, Landseerly regal as the royal infant with her crimped hair, painted with such a dazzling lightness of touch, and of even greater fascination to us is the fact that a square-jawed dwarf is here too, so regally dressed – Velasquez loved to paint dwarves.

Wait though. The mystery does not quite end there. See the king in the shadows at the back, as if framed within a painting? Is he standing there, appraising the scene? Or is this a painting of the king, part lost – like much else – in the gloom of the painting's background? Are we, in short, looking at a mirror image? Or are we the mirror?

# Yet
# Another
# Bloody Martyr
# to the
# Revolutionary
# Cause

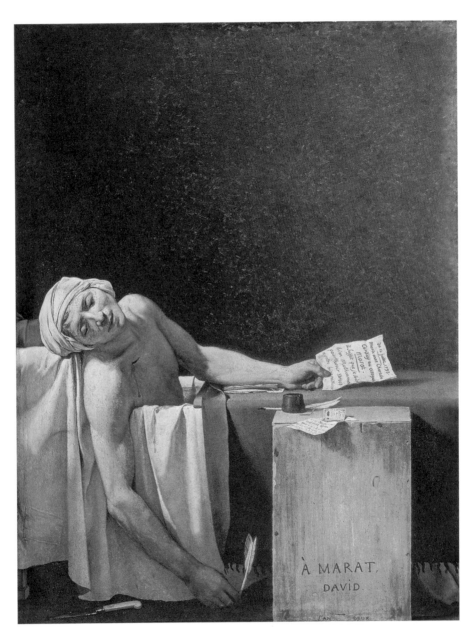

*The Death of Marat* (1793), Jacques-Louis David,
165 × 128 cm (65 × 50 ⅜ in.), Musées Royaux des Beaux-Arts de Belgique, Brussels

**R**evolutions are always such messy affairs – think of how Lenin strained every sinew to correct (or silence) turncoats, former friends... Here we are in the thick of another staging of brutal turmoil, four long years into the blood and factionalism of the French Revolution.

This painting, a species of partisan propaganda, was executed by a man who could easily be denounced as a brilliant cynic. Having been elected to the National Convention as a deputy, and then enthusiastically supported the guillotining of Louis XVI, David later accepted the role of court painter to a new emperor, that sometime upstart from Corsica, and aggrandised him in a series of unforgettable paintings. But just for now, in the summer of 1793, Jacques-Louis David is a revolutionary zealot and friend to Robespierre...

Here we have the death of a secular martyr on our hands, a Swiss journalist and agitator by the name of Jean-Paul Marat. He was killed by a woman called Charlotte Corday – a fragment of her letter, to him, slightly bloodied, is held in the dying man's left hand. She too was a revolutionary – but the wrong sort. She belonged to the Girondists and he to the Jacobins, and so, in her opinion, he had betrayed the spirit of the great cause, and the knife went in – you see it laid out, rather neatly, on the ground beside the tub, painted, smearily bloodied, with such loving care. Almost immediately, David, ever the man to seize the moment, saw in the death of his friend and fellow deputy an opportunity for political propaganda on a grand scale. The painting itself was hung in the assembly hall of the National Convention of Deputies. An engraving was made from it, images widely disseminated.

David did many paintings in the classical manner, investing figures from antiquity with vigorous new life. This is not one of those, and

yet, curiously, this posed death feels classicising in its way. This is a scene of death in a hot tub – Marat was in the habit of taking regular baths to help with a skin complaint – but it could just as easily be a Roman sarcophagus wrapped, almost mummified, by Christo.

The dying man – can there be anything more helpless than a man naked in his bath? – lolls theatrically, blood streaming from his gaping chest wound. That wound sets our mind thinking about a line written by the great Elizabethan dramatist Christopher Marlowe: 'See, see where Christ's blood streams in the firmament'. Marat is a veritable martyr to the cause. This could be a scene staged in a theatre against an austere, monochromatic backdrop. That area of monochromatic uniformity, which consumes almost half of the canvas, brings to mind spiritual boundlessness. The fact that it is Marat, alone with his dying, ratchets up the religious intensity. A great journalist, sometime editor of a newspaper called *L'Ami du Peuple*, and charitable to the last in the cause of liberty, is being taken from amongst us. See how his slumped right hand is still just capable of grasping his quill, which he has been using to give money to one of the needy – the note on the top of the signed crate, together with the cash, tell us that. That splintered crate, with its nails so visible, reminds us that he is a man of the people – this exemplary creature needs no mahogany writing desk! It is a religious picture wholly lacking in overt religious iconography. The revolutionary impulse, death-dealing as ever, is religion enough.

# Misunderstanding
# in
# Carrara Marble

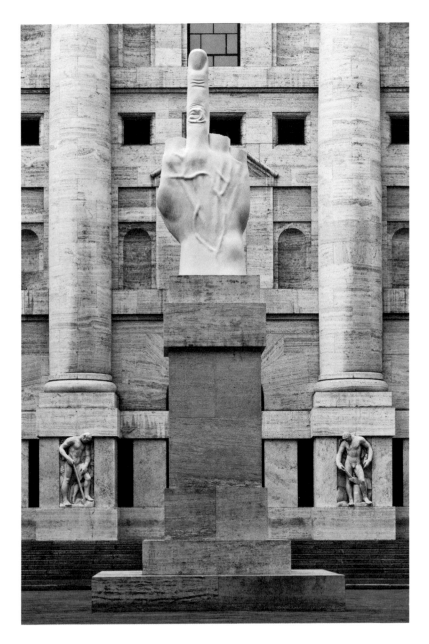

*L.O.V.E.* (2010), Maurizio Cattelan,
1,100 × 470 × 470 cm (433 ¹/₈ × 185 × 185 in.), Piazza degli Affari, Milan

Art displayed in public places is more often than not shocking in its banality and mediocrity. Think of some of the public art of Whitehall or St Pancras Station, for example. We tend to associate the idea of looking at art with visiting great galleries, where there is evidence, everywhere, of curatorial discrimination at the highest possible level. This is seldom so with public art. We find our eyes offended by bland tributes to the dead with their massaged reputations or second-rate attempts at quasi-abstract forms that set the teeth on edge. We are seldom positively shocked – or even mildly disturbed. And almost never uplifted. What shadowy committee can have brought such trash into being? In short, public art is an art which often deserves to be ignored. Thank God for the unpredictable inventiveness of good graffiti!

Here is a piece of public art which looks calculated to shock – and so it did. It appeared in the financial district of Milan in 2010, beside some severe, Fascist-era architecture. It is made by an Italian trickster amongst artists called Maurizio Cattelan. Cattelan seldom makes things. He has ideas for things which he then asks other people to make. He is a hands-off artist who hangs New York City cops upside down on a wall or fells a pope by a meteorite. This looks like a piece of skilfully managed public outrage. And yet much about it might lull us into thinking otherwise. It is immense in scale – the hand, wrist to pointed finger, measures eleven metres high. It is fashioned from white Carrara marble, thereby claiming distant, cheeky kinship with Michelangelo. Its immensity reminds us of Michelangelo too – did he not also wish to impress by the sheer force, scale and gigantism of that tomb, much scaled back when finally realised, for Pope Julius II? This

hand, this pointing finger, looks like a tragic fragment of an immense whole, an Ozymandias-like vestige of some grander might-have-been.

And yet wait a moment. How could anyone describe this hand as grand? Look at the gesture! That brutish, pointing middle finger is a species of brazen insult, and it has been so since time immemorial. Cattelan's hand is surely cocking a snook at the very financial institutions outside which this hand was displayed. This is a blame game. And its appearance there one day, atop this grandiose plinth, quite understandably, provoked uproar.

And yet our first impressions are not necessarily accurate. That gesture of provocation is not quite what it seems. Those other fingers are not in fact furled down at all. They are cut off. Perhaps then this is an image of disability, which just happens to be suggestive of something else. And are not the gestures of disabled people perpetually being misread? And yet is *that* interpretation quite true? Perhaps those chopped-off digits are there to remind us that so much of the great art of antiquity is fragmentary, and that we misunderstand it, tell ourselves wrong or incomplete stories about it, for that very reason. If it had been complete, would this not have been a Fascist salute, praising the monumental context in which it has been displayed?

# The
# Medici Court
# Painter's
# Bewitchingly
# Twisty
# Carnality...

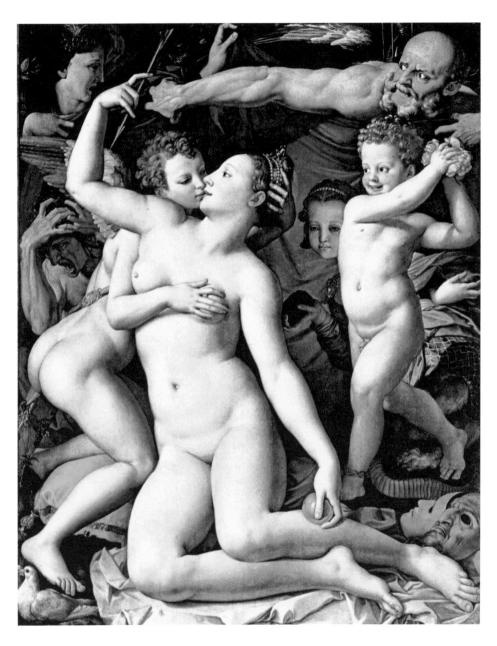

*An Allegory with Venus and Cupid* (c. 1545), Bronzino,
146.1 × 116.2 cm (57 ¹/₂ × 45 ³/₄ in.), National Gallery, London

**B**ronzino, son of a Florentine butcher, and court painter to
Cosimo I de' Medici, could be such a tease. The fact is that we seldom
know quite where we are with him. He possesses this quality of
brilliantly polished evasiveness. His religious paintings are often almost
too erotically glamorous for words. We would die all over again for his
dead Jesus. His portraits of members of the court, gorgeously adorned
adults or plump-cheeked babes, are too glacially reserved for us ever
quite to know what he is thinking about his sitters. Is it liking or
loathing? He lacks human warmth, you could say. He doesn't feel for
his sitters as Rembrandt felt for his. He is intellectually removed.
He scorns or inwardly mocks just as much as he preens and flatters.

But he has so much else by way of compensation. Is it a kind of moral
perversity? Perhaps. (He wrote amazingly filthy poetry.) And one of his
greatest attributes is this ability to force us to forever be holding our
judgements in the balance, never, finally, to go for one thing or the other.
This allegorical painting on the familiar theme of the ongoing dalliance
between Venus and her naughty son Cupid seems to be pointing a fairly
stern moral of sorts, which could be this: always be mindful of what is
going on behind your back. Never trust seeming. At the same time, it is
offering up to us eroticism on a gilded dish, complete with the billowing
of gorgeous fabrics, pink, blue, green, yellow. It is all so pleasing to the
eye, every element of this grand, peacockish display. It is also quite
slippery and malign. Beneath all the suave sheen of its surface glamour,
there are bestial gruntings and heavings.

It calls itself an allegory, and immediately, in our pursuit of the
elusive meanings of that word, we find ourselves thinking forward
just a few decades to a great literary allegory written by the English

poet Edmund Spenser called *The Faerie Queen*. That long, unfinished poem teems with allegorical personages – Lady Una, Gloriana and the rest – whom we never really get to know because they are nothing but uncomplicated embodiments of their moral attributes. Yes, to call something an allegorical figure is to rob it of its full human richness – and I mean by that its inward richness because allegorical figures are allowed to be rich on the surface. Spenser, in fact, is little other than bewitchingly glorious surface adornment. And so it is in this painting too. There is this wonderful surface of bewitchingly twisty carnality – but these are *not* human beings that we are seeing before our eyes. They are weirdly phantasmagorical embodiments of what they represent in the scale of good and evil. This is perhaps one of the reasons why we find ourselves puzzling so much over the fact that they don't quite work as fully realised human figures – and we want them to do that because, in certain respects, this seems to be a shamelessly glamorous presentation of near perfect youthful bodies that we are being invited to sip at, visually. And yet it is not. It is too dreamlike in its play of distortion. We could propose that this is the consequence of Bronzino having bitten off more than he could chew, that he did not quite possess the painterly expertise to get this enormously complicated composition quite right. (This is his first attempt at the theme. The second, in Budapest, is much more straightforward and academic in its approach.) That's nonsense though – he was simply too great a painter. So he has us on the end of a spit, and, quite gently, he turns it. What a tease.

# The
# Thunderous
# Spectacle
# of Sheer
# Water

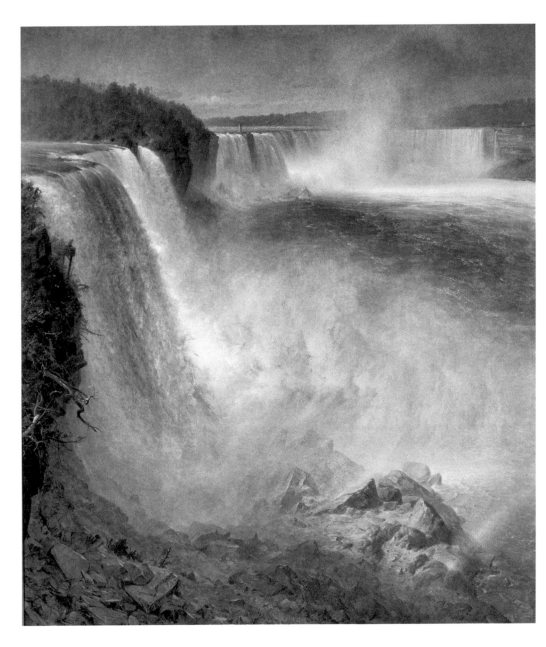

*Niagara Falls, from the American Side* (1867), Frederic Edwin Church,
260 × 231 cm (102 ³/₈ × 91 in.), National Gallery of Scotland, Edinburgh

Water for its own sake. The roiling immensities of water when seen from the cliffs above Le Havre, for example. All that beguiling shape-shifting, all that tonal tricksiness – as Monet would have seen it... Yet how many painters in the Western tradition really took water seriously as a subject for art before the nineteenth century? Answers on the back of a postage stamp perhaps.

The seas were there all right, but they were backdrops to heroic naval skirmishes, a context in which to admire the outlandish, self-preening beauty of ships in full sail. They were also, soberingly, an enduring site of tragedy – there was always death by drowning to provoke a tear. And then, from later on in the eighteenth century, came the Romantic impulse. Water began to take on a life of its own. Two-thirds of the world's surface suddenly became interesting. Quite true? Well, let us say that it was found to have boundless imaginative possibilities in so far as it enabled the boundlessness of the self to be contemplated, boundlessly, and even reflected back at itself. And in the wake of all that shocking discovery of water and its imaginative potential came Turner, Monet and ... Frederic Church.

Here is just one example of water sweeping us away, humbling the spectator as we stare and stare into its terrible, roaring eye. Yes, before the advent of the cinema, there were the paintings of Frederic Edwin Church of New York State. They went on tour. They were kept hidden behind curtains until the moment of revelation, which provoked aahs! of wonderment in the breathless spectator. They were often painted on an immense scale because their themes – the dramatic landscapes of America – called for immensity. By their size, and the sheer pugnacity of their presence, they were a stand-in for the real thing.

No painting is ever innocently topographical. All topographical paintings have designs upon us. How much politics is there here, for example? To what extent does the thundering majesty of the Falls represent, and somehow seem to embody, the muscle-flexing of America, that young, coming nation? Even as we look at it, Woody Guthrie's song in praise of the Grand Coulee Dam begins to play itself inside our heads: 'Well, the world has seven wonders that the travellers always tell...'

Our own angle of view is nerve-wracking. We seem to be on the brink of being engulfed, plunged head-first, into the maelstrom. At its centre, we look down into a kind of thickly glowing nothingness. Those two tiny spectators on the extreme left, standing on what looks like an extremely perilous wooden structure, show us the cowed, awe-struck human element. There is almost nothing but the no-holds-barred muscularity of water. Man must not meddle with this. It is too terrifying and too potent for mere mortals. And yet, Church seems to suggest, this is also, paradoxically, a spiritually benign scene. The way that the sunlight, crossed by the rainbow, falls upon that rocky outcrop at bottom right makes nature seem revelatory in some undisclosed, religiose way. This is a transcendental scene. We are awe-struck before nature's majesty. The fumy, cloud-like mist adds to our sense of slightly befuddled and even nervous awe because we cannot see exactly what it is that we are seeing. We cannot properly register the movement of the water. We cannot quite make out the curve of the Falls. The water, having fallen, with an almighty rush, feels as if it might be being rocked in a great basin. Our eyes grope to make sense of it all, to see exactly where the shoreline begins and ends. In suspense, we are suspended.

And yet the painter has conquered after all. He has reduced all this terror to a spectacle. He has tamed these waters and their capacity to pulverise. It thunders mutely.

# The
# Mute Maker
# in a
# Fatherland
# of Nostalgia

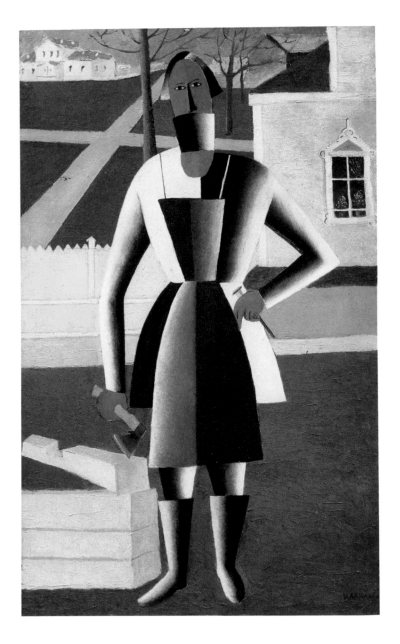

*Carpenter* (1928–29), Kazimir Malevich,
70 × 44 cm (27 ¹/₂ × 17 ³/₈ in.), State Russian Museum, St Petersburg

**D**oes the delicate, fanciful, figurative nature of the painting on the opposite page represent an act of self-betrayal? It is certainly a turning back. Kazimir Malevich seemed to throw down a gage in 1915, when he made the first of his 'Black Square' paintings. That all-over-blackness was an act without compromise, a no-turning-back moment. Painting as a process of imitation was dead. Long live the new, austere, non-representational art! And yet, some years later he turned back – as Giorgio de Chirico was to do also. And he turned back, in part, to what he already knew. The Russian peasantry. And, as he aged a little more – he died in 1935, just six years after he had made this work – he seems even more regressively figurative in his manner of using paint.

What then is happening here? Here is a carpenter, a maker with his hands. He holds an axe, a chisel. This man is Russia. This man is at the heart of things. The wood which he works is on the move, slipping sideways, part-worked, coming into being as an architectural structure of a certain Russian timelessness. See that ornamental window behind him? And yet this carpenter is being seen through the eyes of the stylisations of the modern, all those paintings by Picasso, Matisse and others that Malevich had seen in the Moscow homes of two great collectors, Morozov and Shchukin, earlier in the century, and the later experiments of the so-called Cubo-Futurists. Malevich was in the thick of all that.

And so after blackness and the negation of the world of imitation, colour returns, and shapeliness, in excitable abundance. Blue trees, a pink, cruciform path, red hands. Its giddy, dreamlike dislocation from the reality of all that we see puts us in mind of a line snatched from a poem by Wallace Stevens called 'Disillusionment of Ten O' Clock',

written just three years before this painting was made, which speaks of the old sailor who 'catches tigers in red weather'. We ask ourselves what sort of creature this is, what level of other-reality it is rooted in. Is it a mannequin, a *poupée*, a talisman, an amulet, an icon? All those things and more? It is a fantasia on a dying theme during an era when the sheer brutality of the great collectivist experiment was beginning to transform the nature of life on the land in Stalin's Soviet Union for ever. And so it is wistful then? Yes, but not narrowly so. Wistful for Futurism just as much as it is wistful for the man who might once have proudly commanded the regular sight-lines – Christ-evoking in the cruciformity of those paths – of his own verst of land.

It is a part re-staging of Malevich's own past, and a reaffirmation of a belief in that past – his painting *The Scyther* (1912) is markedly similar to the carpenter in the elongation of the face, the tube-like legs and arms, for example. The great difference is this: the carpenter has been robbed of the powers to express himself through the mouth. Other late paintings of peasants show them with faces entirely featureless. This is therefore also a portrait of the death of dissent.

# Making
# It
# Inside
# Out

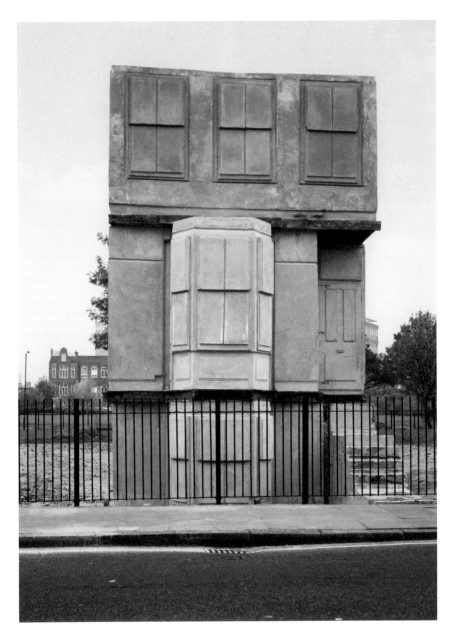

*House* (1993), Rachel Whiteread,
Mile End, London

Great art is often the art which has survived. We then define ourselves, and the world in which we live, in relation to its enduring presence. Questions can swarm around it like so many ghosts in the air. *Is the art of our own times as great as this? Why do we do things so differently now? Are we not getting worse and worse?* But art can also disappear, almost as soon as it has touched down on its plinth, and that can shock us too, because we may have wanted it to survive. Art that exists outside the hallowed space of the art institution or the royal palace, art out in the world, can be especially vulnerable. After all, it may be in the way of the onsurge of modernity – which could mean the wrecker's ball or the footfalls of armies on the march.

This is such a piece, no sooner come than gone, and it was made by a young artist not long after the outset of her career. It was fabricated in order to question our habits of senseless and wanton destruction. Local authorities are often in the habit of destroying old buildings and replacing them with structures less pleasant, less beautiful, less serviceable, and fabricated from materials less durable, less long-lasting, than that which they are replacing – which means, of course, that even if they are not demolished before they grow old, they are likely to survive less long.

What Rachel Whiteread has created here, in this severe concrete cast of a house, is a kind of tribute to the idea of a loved and vanished thing. It is a very curious tribute indeed. Imagine the rubber mould of a jelly. Now imagine turning it inside out. This is the cast of a house turned inside out. We are seeing the inside of a house on the outside. It is not a demonstrably beautiful thing, this house. Yet it is one of a very dependable kind, and when all the examples of that particular

kind are squeezed up together, hugger-mugger, they define something that is very valuable indeed: a neighbourhood. And so it is a tribute to a kind of living. A vanished kind of living.

Being so, we want it to feel warm, as if to prove that it was once alive with human life. And yet it is not warm. It is unremittingly, starkly grey, as if in confirmation of the fact that what it shows – the house that it appears almost to replicate – no longer exists. The lights have gone out. Nor does it look quite like the house, not entirely, because it has been wrenched out of its context amongst other houses in order to exist in this state of wretched and lamented isolation, as a symbol of what would once have been. It feels too sharply cut off, pared back, trimmed down, as if by scissors. And then there is the blankness of those windows. Those blank rectangular shapes exist in order to stop us looking, stop us imagining what might have gone on inside. They challenge us to be curious. And then they stop us being curious. This, once again, feels like a tilt against those who chose to demolish this house. Look what you have done, these blank windows seem to say. Look what you have so wantonly negated here.

*House*, sited in Grove Road, Mile End, survived for just eleven weeks. It was demolished by Tower Hamlets Council on 11 January 1994.

# Biographies

**Ai Weiwei** (b. 1957). Born in Beijing, he and his family were exiled to Xinjiang, Northwest China, in 1958, his poet father having been accused of 'rightism'. He lived in New York from 1981 to 1993. On his return to China, he co-founded Beijing East Village, an experimental artists' cooperative. His passport was confiscated in 2014.

**Avercamp, Hendrick** (1585-1634), born in Amsterdam, was the undisputed master of winter landscape painting during the Dutch Golden Age. His dynamic, panoramic scenes, usually painted on wooden panels or copper, bring an entire society to vibrant life – its manners, its fashions, and even its street games.

**Bellini, Giovanni** (1530-1616) was one of the greatest of the Venetian painters of the Renaissance, whose subject matter encompassed sacred themes, secular portraiture and historical narrative. He pioneered the use of oil painting, and became celebrated for his tonal range and the richness of his colour.

**Blake, William** (1757-1827) was one of the greatest artists and poets of the English Romantic tradition. Almost entirely neglected during his lifetime and long after, he held just one exhibition (above his brother's shop), which was commonly regarded by the critics as a resounding failure. His poetry is just as important as his paintings, drawings and prints, though his Prophetic Books often descend to breathtaking depths of obscurity. He was dictated to by angelic beings, and he recorded their presences for posterity to contemplate.

**Bosch, Hieronymus** (1450-1516) was a Netherlandish painter born in Hertogenbosch. Although a deeply religious man, many have regarded him as a heretic for his often wild and fantastical visions and free use of religious symbolism. Closer to our own day, he was championed by the Surrealists as a forefather – a man who could make free and unbridled use of his own dream visions. Bosch, a highly respected member of a religious community, would probably have been shocked and dismayed to find himself in such company.

**Boudin, Eugène** (1824-98), a forerunner of Impressionism, was born and brought up in Le Havre. A painter of sea, sky and fishing boats, he was also fascinated by those exotic and overdressed species who flocked to the seaside from far-flung parts to savour the ever shifting ocean's strange delights. As with the Impressionists, he was quite besotted by the effects of light.

**Bourgeois, Louise** (1911-2010), born in Paris, worked as a child in her parents' tapestry workshop in Choisy-le-Roi. In 1930, she entered the Sorbonne, where she studied mathematics and geometry. Her life changed direction in 1938, when she married the American art historian Robert Goldwater, with whom she moved to New York City, where she continued to live until her death in 2010.

**Bronzino** (Agnolo di Cosimo di Mariano, 1503-72) was born in a suburb of Florence. His paintings, supremely aristocratic and formal in manner, seem to embody the icy splendour of the Medici court of Cosimo I. In addition to his painting, he also had great talents as a poet, and he was a member of the Accademia Fiorentina.

**Bruegel the Elder, Pieter** (c. 1525–69) is almost as mysterious as some of his paintings. He may have been born in a village called Bruegel, which is close to Breda in the Netherlands, though no one is quite sure. It is very likely – but by no means certain – that he went on to study in Antwerp with a master called Pieter Coecke van Aelst.

**Caravaggio** (Michelangelo Merisi, 1571–1610) had a relatively short and brutal life. He brought naturalism to new heights by painting directly from the model, and he injected into the art of painting an extraordinary sense of drama – due, in part, to his revolutionary way with lighting. Some of his earliest paintings were gorgeous still lifes. By the middle of the 1590s he was working in Rome, and beginning to paint religious paintings on a large scale, some of which were regarded as vulgar and sacrilegious. He fled from Rome after killing a companion in a brawl.

**Cattelan, Maurizio** (b. 1960), born in Padua, is a multi-media artist who now lives and works in New York. For many years he cleaned floors, cooked, donated sperm, and worked as a postman and mortuary assistant. He is generally regarded as a post-Duchampian joker, undermining settled systems of power and influence.

**Cézanne, Paul** (1839–1906) was born in Aix-en-Provence, the son of a prosperous banker whose wealth enabled his son to live free of financial fetters. Although destined by his father to study law, he was allowed from the age of twenty-two to devote himself to painting. He died of pneumonia, having been caught in a storm while working in a field.

**Church, Frederic Edwin** (1826–1900) was an American landscape painter on the grand scale whose monumental canvases left spectators feeling humbled, awe-struck and bursting with nationalistic pride. Closely associated with the Hudson River School of painters, he built himself a mansion called Olanna in the Moorish style just outside Hudson, New York State.

**Constable, John** (1776–1837) was an English painter born in East Bergholt, Suffolk. His father was a grain merchant and mill owner. In 1816 he married Maria Bicknell, whose father regarded Constable as socially inferior. She bore him seven children. Now regarded as amongst the greatest of English Romantic painters, he enjoyed little success during his lifetime.

**da Fabriano, Gentile** (1370–1427) was born in the Marche region of Italy and worked as an itinerant artist, principally of religious scenes, and mainly in Tuscany. His style is loosely described as International Gothic, but the fact is that he also incorporated stylistic elements of the Florentine Renaissance into his art as a result of working in that city.

**David, Jacques-Louis** (1748–1825) was born in Paris, though he later studied in Italy. During the French Revolution, he was a member of the National Convention and was responsible for feasts and public spectacles. He later turned tail and became court painter to Napoleon. He died in Brussels.

**de Chirico, Giorgio** (1888–1974) has long been regarded as one of the founding fathers of Surrealism, which had not yet been brought to birth by the cantankerous André Breton

when *The Uncertainty of the Poet* was painted. In later life, de Chirico returned to a mode of classicism, and disowned much of his earlier work as the antics of a juvenile.

**de Hooch, Pieter** (1629–84) is first mentioned as a 'painter and footman' in the house of a rich merchant. He was born in Rotterdam, the son of a bricklayer and a midwife. He died in Amsterdam, in an insane asylum.

**Dubuffet, Jean** (1901–85) was a French painter and printmaker who embarked on his career as artist in late middle age, having lived the life of a prosperous wine merchant until then. Dubuffet's work has a wild, childish, naïve quality to it. A great collector of Art Brut (he himself coined the term), he will always be regarded as one of its greatest practitioners.

**Dumas, Marlene** (b. 1953) was born in Cape Town, South Africa, and was raised on the family's vineyard in the Kuils River region. Afrikaans was her first language. She studied painting at the University of Cape Town's Michaelis School of Fine Art before moving to the Netherlands in 1976. She currently works in Amsterdam.

**Dürer, Albrecht** (1471–1528) was born in Nuremberg, one of between fourteen and eighteen children. His father, who was born in Hungary, taught him the fundamentals of goldsmithing and drawing. Engraver, painter, printmaker, mathematician and theoretician on such matters as perspective and ideal proportion, Dürer was brilliantly precocious and became famous throughout Europe for his extraordinary woodcuts.

**El Greco** (Domenikos Theotokopoulos, 1541–1614), nicknamed 'The Greek', and born on the island of Crete, trained as a painter of Byzantine icons. Before the age of twenty he moved to Venice, where he worked under Titian, and then later to Rome. He spent the greater part of the rest of his life in Toledo, where he painted many of his most important paintings. Regarded as a mediocrity until the beginning of the twentieth century, he was dramatically reclaimed by the moderns as a precursor of everything they were striving to achieve.

**Ensor, James** (1860–1949) lived his entire life above his mother's curiosity shop in Ostend, Belgium, and from that shop some of the most characteristic motifs of his paintings emerged: skeletons, skulls, carnival masks. He is best remembered for his mask faces, distorted, grotesque, ever inclining towards the comic and the ridiculously macabre.

**Fini, Léonor** (1908–96), painter, illustrator and set designer, was the daughter of an Italian mother and an Argentinian father. Born in Buenos Aires, she was raised as a child in Trieste. Largely self-taught as a painter, in the 1930s she moved to Paris, where she became acquainted with many members of the Surrealist movement, including Paul Eluard, René Magritte, Salvador Dali and Max Ernst. In addition to being a prolific painter, she also illustrated works by Edgar Allan Poe, Charles Baudelaire and Shakespeare.

**Fragonard, Jean-Honoré** (1732–1806) was born in Grasse, France, the son of a glove-maker. His father wanted him to train as a notary, but his skills as an artist were too great to be gainsaid. The French Revolution deprived him

of almost all his aristocratic patrons, and he died in Paris virtually forgotten.

**Friedrich, Caspar David** (1774–1840) was a leading German Romantic painter of his generation who first studied in Copenhagen and later settled in Dresden. He had a predilection for scenes of an almost chilling loneliness and sublimity, in which the human element is cowed into submission and almost overwhelmed by the overbearing grandeur of nature in all its unknowable immensity, and its stark, craggy bleakness, complete with the most mysterious of lighting effects.

**Gentileschi, Artemisia** (1593–1652) was the most accomplished female painter of the Italian Baroque. The daughter of a painter, she was raped by Agostino Tassi, a friend and collaborator of her father's. A recent biography speculates that the rage contained in this painting is a direct expression of the fact that her rapist was pardoned by the Grand Duke of Tuscany. She is known for her fearlessly faithful depiction of women.

**Grünewald, Matthias** (c. 1470–1528). Very little is known about Grünewald and fewer than a dozen paintings can safely be attributed to his name. In 1505 he was doing apprentice work in Frankfurt on an altarpiece for Albrecht Dürer. According to a German art historian, he was melancholy, withdrawn and unhappily married.

**Klee, Paul** (1879–1940) was born near Berne in Switzerland. His glowing and translucent watercolours, often resembling jewel-like miniatures, bear us away into alternative elsewheres. In spite of the seeming child-like naivety of his vision, his art is always underpinned by rigorous theoretical questioning.

**Leonardo** (Leonardo da Vinci, 1459–1519), Florentine inventor, painter, architect, sculptor, draughtsman, town planner, writer, musician and inscrutable penman, was born the son of a mere notary. He trained under Andrea Verrocchio, and came under the patronage of Lorenzo de' Medici. His years in Milan, where he served as court painter to Ludovico Sforza, were some of his most productive. In spite of his extraordinary reputation, he left relatively few fully authenticated paintings to remember him by.

**Malevich, Kazimir** (1879–1935), the first of fourteen children, was born near Kiev into a family of ethnic Poles, and raised a Roman Catholic. His father managed a sugar beet factory. He moved to Moscow in 1905, and fell under the influence of Post-Impressionism. A theorist and teacher, he is best known for the creation of Suprematism, a purist form of abstraction.

**Manet, Edouard** (1832–83) was a French painter born into a family of great prosperity – his mother was the daughter of a diplomat and goddaughter of the Swedish Crown Prince – in the Rue Bonaparte in Paris. His father was a French judge who expected him to pursue a career in the law. In defiance of his parents' wishes he devoted himself to painting, provoking public ridicule by depicting modernity as he saw it, though he maintained throughout his life a craving for public recognition. He died at the age of fifty-one of rheumatism and untreated syphilis. Days before his death, his gangrenous foot was amputated.

**Mantegna, Andrea** (c. 1431-1506) was one of the master painters and engravers of the Northern Italian Renaissance. A number of his great early Paduan frescoes were destroyed during the Second World War. Some of his greatest works are to be seen in Mantua, where he served as court painter to the Gonzagas, and illustrated incidents in the lives of his patrons. The ceiling of the Camera degli Sposi is a triumph of illusionistic perspective.

**Masaccio** (Tommaso di Ser Giovanni di Simone, 1401-28) was born in the Tuscan province of Arezzo. His father was a notary and his mother the daughter of an innkeeper. The name by which we know him means gauche Tom, and he was famous for being impractical. The sheer brilliance of his austere realism made him one of the great innovators in European art.

**Matisse, Henri** (1869-1954), the son of a wealthy grain merchant, was born in northern France, went to Paris to study law, and became a court administrator. He began to paint at the age of twenty after a period of confinement made necessary by an attack of appendicitis. It was a journey into paradise from which he never returned.

**O'Keeffe, Georgia** (1887-1986), who was married to the celebrated photographer Alfred Stieglitz, grew up in the American Midwest and spent much of her life in the wilds of New Mexico. Her painting helped to re-define the American painterly idiom during the 1920s in reaction against the dominant aesthetic of Europe. It has been loosely described as 'magic realism', which means that she invested real things with a

kind of heightened aura of singularity which at times drifted in the direction of Surrealism. Many of her greatest paintings were of flowers and New York City. She painted flowers with a ferocious and almost brutal panache.

**Rembrandt** (Rembrandt Harmenszoon van Rijn, 1606-69) was born in Leiden in the Dutch Republic, the ninth child of a relatively prosperous family – his father was a miller and his mother a baker's daughter. He suffered many personal crises – only his fourth child, Titus, survived into adulthood – and he often invested his considerable income unwisely.

**Schiele, Egon** (1890-1918). Schiele's violently decadent portraiture had a huge influence upon the way in which the human figure came to be represented in the twentieth century. Tense, unwholesome, the site of perpetual warfare or, at best, unease, Schiele's paintings saw their maker fling into the trash bin centuries of oozy, woozy, easily won sentiment, with all those strangely elongated limbs and his wretched, on-the-edge models, whose depiction seemed to reveal a mixture of revulsion and dangerous erotic charge.

**Serra, Richard** (b. 1938) is an American sculptor born in San Francisco. His father, who worked as a pipe-fitter in a shipyard, was a Spanish native from Mallorca and his mother a Russian Jewish immigrant from Odessa. He was working in the steel mills at seventeen years old, and later studied at the Universities of California and Yale.

**Siqueiros, David Alfaro** (1896-1974) was a Mexican painter and muralist born in Chihuahua. One of three children, he studied

at the Academy of San Carlos and the Escuela al Aire Libre of Santa Anita. His work, often social realist in style, embodies the spirit of revolutionary struggle. A tempestuous character, he was often at war with the authorities.

**Twombly, Cy** (1928–2011) was an American painter, photographer, calligrapher and sculptor born in Lexington, Virginia. His father was a pitcher for the Chicago White Sox. He studied at the Art Students League of New York and at Black Mountain College, where he met Robert Motherwell and Franz Kline. In 1957 he went to live in Europe, marrying the sister of his patron. He died in Rome.

**Utagawa Kuniyoshi** (1797–1861) was born in the city of Edo (now Tokyo). He was hugely prolific as a printmaker, and his work encompassed an enormous range of moods and manners. He could evoke the pathos of a dying samurai warrior, the seductive beauty of a courtesan or the impish humour of a wild animal. His work is astonishingly zestful, and it appears to anticipate so much of the popular art of the twentieth century.

**Velasquez, Diego** (1599–1660) was born in Seville into a family of minor nobility, and he served as court painter to Philip IV of Spain, at a time when the kingdom was edging towards bankruptcy. In 1618 he married Juana Pacheco, by whom he had two daughters. He died of a fever.

**Vermeer, Johannes** (1632–75) of Delft, painter and art dealer, was little appreciated during his lifetime. Now his paintings – fewer than forty are known to exist – are amongst

the most prized of all. He seems to intensify our visual appreciation of the world of the domestic interior, to raise up the humdrum to an exquisite pitch.

**Whiteread, Rachel** (b. 1963) was born in Ilford, Essex. Her mother was an artist and her father a geography teacher. She is one of three sisters. She studied at Brighton Polytechnic and the Slade School of Fine Art in London. An early job involved fixing lids back onto coffins in Highgate Cemetery. She had her first solo show in 1988, and won the Turner Prize for *House* in 1993.

**Wright of Derby, Joseph** (1734–97) was best known for his paintings of industrial scenes, and for his dramatic use of lighting – furnace light, candle-light. He painted hard-bitten toil in the workshops and the forges of the Industrial Revolution. At one time in his career, he had ambitions to be a successful portrait painter, but Gainsborough beat him at that ruthless game.

**Yayoi Kusama** (b. 1929) was born in Matsumoto City, a small provincial town in Nagano Prefecture, into a family of high social standing. Her mother strongly resisted Yayoi's wish to become an artist, but art poured out of her from her earliest years like blood from a wound. She made her reputation in New York City, where she moved in 1957, and she did not return to Japan until 1973. Her later life has been spent in Tokyo, shuttling between the hospital in Shinjuku, where she lives, and her studio, which is close by.

# Picture Credits

# Acknowledgements

To my late sometime nearest and dearest, staunch Sheffielders all.

I must ask myself as honestly as possible: what has this family of mine bequeathed to me?

My mother Dorothy gave me her undying love, and a horror of almost all social situations involving more than two people, the first of these being myself. And this horror includes at best a deep-seated unease, and at worst a boundless dread, of finding myself trapped in a chair, any chair will do, for hours at a time, around a dinner table, lit with candles perhaps, in the company of relatives or near strangers. Hearing her express so many rash, ridiculous and wrong-headed opinions about the world and its peoples has bequeathed to me a kind of bullying, boorish rashness too, which has served me well when in the employ of newspapers. To my grandfather Harold, survivor of the Somme, I owe a boundless anxiety about falling headlong into pennilessness, of being reduced once again to the status of a shiftless gutter-snipe; and also an unstoppably wilful determination to pursue my own endeavours as a writer through the thickest and thinnest of grey Yorkshire skies. And to my dear Uncle Ken, I owe what I have learnt as a writer, that power to be cloistered, shored up, inside myself, and to incubate there my own laughably extravagant dreams of penmanship.

Prestel Publishing Ltd.
14–17 Wells Street
London W1T 3PD

Prestel Publishing
900 Broadway, Suite 603
New York, NY 10003

Library of Congress Control Number is available; British Library Cataloguing-in-Publication Data:
a catalogue record for this book is available from the British Library

Editorial direction: Lincoln Dexter
Copyediting: Sebastian Manley
Design and layout: Amy Preston and Amélie Bonhomme
Production management: Friederike Schirge
Separations: Reproline Mediateam
Printing and binding: TBB, a.s.

Printed in Slovakia

Verlagsgruppe Random House FSC® N001967
Printed on Tauro Offset

ISBN 978-3-7913-8301-9

www.prestel.com